FROM LPK
CHRISTMAS 2016

# GREAT
# STORMS
## —— OF THE ——
# CHESAPEAKE

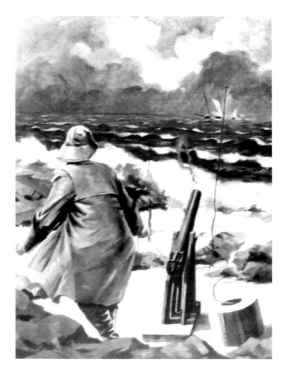

This dramatic illustration of a lifeline being fired from
shore to a wrecked ship graced the cover of a 1920
edition of *The Scientific American*. The line could be used
to carry the stranded crew to shore using a basket or
safety harness. *Courtesy Library of Congress.*

# GREAT STORMS

## STORMS

### — OF THE —

## CHESAPEAKE

DAVID HEALEY

FOREWORD BY BERNADETTE WOODS

THE
History
PRESS

Published by The History Press
Charleston, SC 29403
www.historypress.net

First published 2012

Manufactured in the United States

ISBN 978.1.60949.404.9

Library of Congress Cataloging-in-Publication Data

Healey, David.
Great storms of the Chesapeake / David Healey.
p. cm
Includes bibliographical references and index.
ISBN 978-1-60949-404-9
1. Storms--Chesapeake Bay Region (Md. and Va.) 2. Natural disasters--Chesapeake Bay
Region (Md. and Va.) 3. Weather--Chesapeake Bay Region (Md. and Va.) 4. Chesapeake
Bay Region (Md. and Va.)--Climate--HIstory. I. Title.
QC959.C58H43 2012
363.34'92109752--dc23
2012034054

# CONTENTS

# Contents

# FOREWORD

What storm do you remember most? We all have one. It may be an enjoyable one, when you got to play in the snow and drink hot chocolate after a blizzard shut down your school. Or it may be something a little more serious, like when you lost power for days from that beast of a windstorm called a derecho.

After all the crazy storms I have dissected, tracked and forecast, the one I remember most came when I wasn't even working. It was August 28, 2011. Hurricane Irene was charging up the East Coast. The storm was still a Category 1 hurricane as its center brushed the mouth of the Chesapeake, throwing bands of flooding rain and damaging winds back through the I-95 Corridor. I was six months pregnant with twins and had already been on hospital bed rest for four weeks. As the eye of Irene passed by Baltimore, I gave birth to my twin sons. Yes, they were premature and came way too early, but my husband and I think that they just didn't want to miss a good storm. Don't worry, I was still able to check computer models, follow the National Hurricane Center updates and watch every news report that my remote could keep up with before I delivered the boys!

Outside of giving birth during a hurricane, the back-to-back blizzards of 2010 will forever stand out in my memory—not just for the multiple days I spent on an air mattress on the studio floor with co-workers and bosses but for the sheer power that the atmosphere can deliver. The entire news station was called to action as the first blizzard started dropping its first flakes here in the mid-Atlantic. As we plowed through hours of continuous coverage from a storm that dumped between two and three feet (yes, feet) of snow

around the state, the computer models kept indicating a second storm to follow. No one in the newsroom believed me when I told them. However, after some convincing, they realized that we needed to prepare for a second blizzard that would hit us just three days after the first one ended. The second blizzard encased us with another eighteen to twenty-four inches of snow, contributing to new all-time monthly and seasonal snowfall records for Baltimore. Schools were forced to cut into their summer vacation just to finish the year, while the federal government had to shut down for an unprecedented six straight days.

In this book, David Healey does a great job of taking us back through the storms that helped create and, in some cases, define our history here in the Chesapeake region. We all know Baltimore's success as a port town. But did you know that there was a time when Charlestown, Maryland, was challenging Baltimore for that position? That was until a hurricane roared up the coast in the late 1700s with a twelve-foot tidal surge. Between the track of the storm and the depth of the waters surrounding each town, Baltimore came out of the storm in much better shape than Charlestown, which never really recovered.

He also explores how weather influenced transportation. Did you know that continuous rail service between Philadelphia and Baltimore was not fully established until 1866? That's years after the rail system was operating throughout the Northeast. Passengers would get off one train on the north side of the Susquehanna River, cross the water by ferry and re-board a different train on the other side of the river. After a few brutally harsh winters that froze the river solid, engineers were forced into drafting and eventually building a bridge. All because of Mother Nature.

Weather has shaped our history and continues to influence us on a daily basis. David illustrates some of the major moments up to this point, but the weather never stops. Just when we, as meteorologists and forecasters, start to figure out some of Mother Nature's patterns and plans, she always throws a new lesson our way. Enjoy!

Bernadette Woods is an Emmy Award–winning meteorologist for WJZ-TV Channel 13 in Baltimore.

# PREFACE

*This is a world apart, untamed and bleak*
*These lonely marshes of the Chesapeake.*
— *Gilbert Byron*

When you set out to write about the greatest storms of the Chesapeake Bay region, what you quickly realize is how the anecdotes and facts pile up around you like snow in a February blizzard. Four hundred years of hurricanes and nor'easters, blizzards and gales, waterspouts and hailstorms is a lot of weather to cover.

Again and again, I've been reminded that weather is one of the last wild things on the planet, far beyond human control. Weather sometimes comes with a terrible beauty, as anyone who has watched a July thunderstorm or February blizzard can attest. Weather can catch our eye like a swimsuit model, but better watch out—she's wearing a barbed-wire bikini. And while it's true we've come a long way in predicting and understanding the weather since English explorer Captain John Smith encountered his first Chesapeake Bay squall, there's not much we can do to change or control it.

As a lifelong Marylander, two weather incidents stand out in my childhood memory. The first is Tropical Storm Agnes in 1972. I hadn't started kindergarten yet at Lisbon Elementary School, but I can recall how my father drove us a couple of miles down to the Route 97 bridge over the south branch of the Patapsco River. The river marked the boundary between Howard and Carroll Counties. Most of the time, the Patapsco was placid, not much more than a large stream that one could easily wade across.

Sometimes we hiked a little way along the railroad tracks beside the river, and as a boy, I loved to collect lumps of coal and stray spikes and empty shotgun shells left behind by dove hunters.

The deluge of rain from the tropical storm transformed the river. Even the stream on our farm had overflowed, flooding the lower fields. Our stream, which J.E.B. Stuart's troopers had splashed across on their way to Gettysburg, was yet another tributary of the Patapsco. The river was now raging as all this water flowed toward the Chesapeake Bay. The bridge was gone, washed away by the rushing waters that now roared as loud as Niagara Falls to my ears. All these years later, the memory of that muddy, raging river remains burned into my mind.

We were watching the river from high ground and at a safe distance. Downstream, at Ellicott City, the flood had turned deadly. Several victims would die there in the high water. As I discovered in the research for this book, it was not the first time that the Patapsco—normally so calm it could scarcely be called a river—had turned into a dangerous torrent that swept right into downtown Baltimore.

My second weather memory has to do with one of Maryland's great snowstorms, the Presidents' Day Blizzard of February 18–19, 1979. It would go down as the worst snowfall in almost sixty years.

My parents were in the greenhouse business, raising flowers and vegetable plants from seedlings. Dad also had a full-time job at the Social Security Administration complex in Woodlawn, where, among other things, he was in charge of snow removal. So the night of the storm he was at work, leaving my mother, me and my two younger brothers to clear the snow off our greenhouses. If not knocked off with brooms, the sheer weight of the snow could crush the plastic and metal pipe structures, along with the tiny plants inside.

This blizzard remains one for the record books not only for the extreme cold and the twenty-six inches of snow that fell but also because of how quickly the snow came down. Rates of up to three inches per hour were recorded. Half frozen, we worked right through the early morning hours to keep ahead of the snow, but it was no use. One by one, the greenhouses collapsed under the weight of the snow.

If there's a lesson here in these childhood memories, it's that weather has consequences and deserves respect. That's something worth remembering, even if we're lucky enough to be keeping an eye on the storm from the living room window. What you will find here is a collection of weather stories from across the Chesapeake region. Some are tragic, some are noteworthy for breaking all records and some are simply quirky.

# PREFACE

When we talk about the weather, it often seems like a harmless way to make small talk and pass the time with friends and strangers alike—especially the ones in line with us at the supermarket to buy bread and milk before the next big storm. But as we'll see in the pages to come, when it comes to the weather, it's anything but a dull topic.

# PART I

# THE 1600s AND 1700s

This postcard view of a stormy sea shows an old-fashioned schooner riding the waves far from shore. *Courtesy Historical Society of Cecil County.*

# NEW WORLD TEMPESTS

## WITCHES, HURRY-CANES AND LEGENDARY STORMS

*Now would I give a thousand furlongs of sea for an acre of barren ground, long heath, broom, furze, anything. The wills above be done, but I would fain die a dry death.*
—*William Shakespeare,* The Tempest

As the new year of 1612 approached, a play by William Shakespeare opened in the London theater. For Shakespeare, who had written about everything from star-crossed lovers to a tormented Danish prince, the subject of this play was something entirely new and different. *The Tempest* was the story of a cast of characters shipwrecked on a remote island. Shakespeare's play was almost certainly inspired by a real-life storm and shipwreck experienced by travelers to the New World. Mixing magic and romance, this was a story in which the storm itself became a character. When it came to the New World and all its promise, even the storms were unlike anything the Old World had ever known.

It's hard for us today to imagine the excitement that swept through England and Europe at the very thought of the New World. The closest comparison might be if some new planet were found to be lush and inhabitable, only in need of settlers willing to make the voyage across the stars. It was a land that promised a fresh order beyond the influence of kings and princes. Tales reached England and Europe of vast empty lands, untamed forest, wild savages and incredible sights. Those who never intended to visit the New World must have found themselves daydreaming about the possibilities of this newfound land. Shakespeare had heard the stories and journeyed there in his imagination.

On August 4, 1609, a small fleet carrying the future governor of the Virginia colony, Sir Thomas Gates, sailed into a "most terrible and vehement storm" that descriptions say lasted forty-four hours. The suffering aboard the tiny ships must have been beyond description. One ship sank, others were scattered and a few made it to the Chesapeake region. The colony of Maryland had not yet been founded.

The *Sea Adventure*, carrying Sir Thomas, was damaged and blown far off course but managed to make landfall in the uninhabited island of Bermuda. Over the next ten months, he and the crew were able to crudely repair their storm-battered ship and then complete the journey to Virginia.

While there were storms in England, there was nothing like the tempest encountered by Sir Thomas. These New World storms were something altogether different, as alien as the strange beasts and lands to which they belonged. They were massive and destructive in a way that had never been experienced. These storms even warranted a new name: hurricane. The word itself comes from Spanish explorers, who in the 1500s named these terrifying tempests *huracán* after a storm god of the native peoples they encountered in the Caribbean.

The storms that eventually become tropical cyclones—hurricanes—generally get their start as thunderstorms over the African continent. Some of these storms intensify as they move out to sea and gather energy from the warm tropical water. Due to the Coriolis effect, the volatile cloud mass begins to spin, moving clouds and energy high into the atmosphere. As the storm continues to grow, it siphons more warmth and energy from the sea. Eventually, the storm system takes on the trademark shape we know so well from modern satellite images—kind of like cotton candy swirling against a deep blue background. From high above, the storms hardly look like such savage tangles of winds and rain.

Some such storms hang together and come ashore as real beasts, still fully formed. Others lose their energy as they move over cooler water or land yet still contain enough energy—released in the form of rain and wind—to do serious damage.

For the first Europeans in the New World, even summer thunderstorms were strange and terrifying. One of the first Englishmen to encounter a Chesapeake Bay squall—and live to tell the tale—was Captain John Smith. With a crew of fourteen in an open boat, Smith ventured out from Jamestown in June 1608 to explore and map Chesapeake Bay. They soon encountered one of the summer squalls that seem to blow up out of nowhere. These squalls today send boaters running for port and can terrify those caught

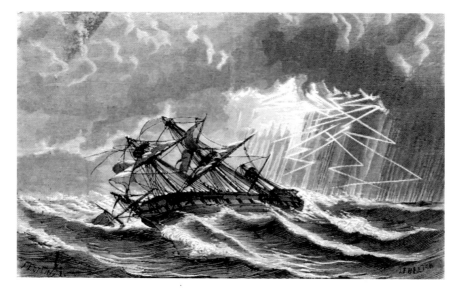

Disasters at sea captivated the popular imagination during the nineteenth century, as captured in this engraving of the ship *Ouragan* meeting its doom in the Atlantic. *Courtesy Library of Congress.*

in the sudden winds and waves. Far from any help and in a slow-moving open boat, Captain Smith and his men could only try to ride it out. Smith wrote about the experience: "We discovered the winde and the waters so much increased with thunder, lightning and rain that our mast and saile blew overboard, and such mighty waves overracked us in that small barge that with great labour we kept her from sinking by freeing out the water."

The damage was such that the explorers had to land for two days and make repairs. "We were forced to inhabite these uninhabitable Isles which for the extremitie of gusts, thunder, raine, storms and ill weather, we called Limbo. [Then] repairing our saile with our shirts, we set saile for the maine and fell in with a pretty convenient river on the East called Kuskarawaok [the Nanticoke River]."

The weather in this New World was of great interest not only to future colonists but also to curious Old World weather watchers. Then, as now, observing the weather was very much a popular pastime among people from all walks of life. In *A Relation of Maryland*, published in 1635, the writer praises the weather in the colony: "The temper of the Ayre is very good, and agrees well with the English...In Summer it is hot as in Spain, and in Winter there is frost and snow; but it seldom lasts long. The windes there are variable; from the Souths comes Heat, Gusts, and Thunder; from the North,

or North-West, cold-weather, and in Winter, Frost and Snow; from the East and Southwest, Raine."

If the writer seems to have downplayed the worst of the weather, it should come as no surprise that he was writing a kind of travel brochure to lure potential immigrants. These optimistic or favorable descriptions were thus to be expected.

At a time when the cause of storms was beyond the knowledge of even the most educated scientists, a great deal of superstition still went hand in hand with attempting to understand and predict the weather, and these superstitions were heightened at sea. Several accounts of voyages to the New World describe how desperate, storm-tossed passengers sought to blame the bad weather on a witch aboard the ship. In some cases, the crew and passengers settled on a likely suspect and threw her overboard. This murderous act did nothing to lessen the effects of the storm except in the survivors' imaginations, but it probably did rid the ship of an annoying old nag.

## "THERE WAS NOTHING THAT COULD STAND ITS FURY"

One of the first major storms to impact early settlers around Chesapeake Bay was the Great Hurry Cane of 1667. No weather records or official observations existed at that time. But from the descriptions that survive to this day, there is little doubt that this was one of the Chesapeake's worst storms, historically speaking.

Early on the morning of September 5, 1667, the red ball of the sun rose on a hazy horizon. Those going about their morning chores may have hoped for a breath of wind to stir the morning air. It had been unusually hot in the Chesapeake, as the newly settled region was called.

The Chesapeake regions of Maryland and Virginia are defined as subtropical climates with humid summers and relatively short winters— albeit winters that can have weeks of intense cold. This was a steamy region, indeed, in comparison to the damp, gray, chill weather of England. Summer heat began early and stretched deep into September or even October. The humid air could get so thick that you could almost feel it weigh on your shoulders, making every chore that much more difficult.

The climate and the living conditions could be hard on newly arrived settlers, who still came decades after the *Ark and the Dove* first landed at St.

Mary's City in March 1634. Lord Baltimore's colony had expanded greatly since then, but living conditions had not improved much.

Newcomers often went through an adjustment called "seasoning." The new arrivals' immune systems were adapted to European climates and illnesses. Settlers almost always fell ill from a combination of the new diseases inherent to the Chesapeake, particularly fevers of one sort or another. Those who survived might later fall victim to recurring malaria or what writers of the time called "grypes of the gutt"—basically sickness caused by spoiled food or contaminated water.

Then there was the heat and humidity and allergies to new forms of pollen, plus a sparse diet that left the new settlers weak. Some did not survive this seasoning, and those who did were not always robust. Few men lived beyond their forties, and an amazing seven out of ten immigrants died before reaching age fifty. Women fared no better, with childbirth and burns from cooking fires being the leading causes of death. In the Chesapeake, orphans were far more common than children with one or two surviving parents. Writing in *Maryland: A Middle Temperament*, historian Robert J. Brugger notes that just 6 percent of fathers in the Chesapeake lived to see their children grow up. Harsh conditions, to be sure, but ones that newcomers were willing to endure for the opportunities offered by the New World.

Extreme weather of one kind or another did little to lessen the misery of the Chesapeake's early European inhabitants. The hot summers and cold winters likely only hastened the deaths of settlers already in a weakened condition.

It is perhaps a testimony to this hard life that so few of the Chesapeake region's early houses survive. Most were of post-and-beam construction that has long since rotted away. Another century would pass before the substantial brick homes of the Tidewater gentry appeared. Chesapeake houses of the 1600s were practical and transient. "The dwellings are so wretchedly constructed that if you are not so close to the fire as almost to burn yourself, you cannot keep warm, for the wind blows through them everywhere," noted one early traveler.

This was the setting that the sun rose upon that morning before the storm nearly four hundred years ago. The settlers must have noticed the sunrise in passing, and a few old sailors may have grumbled about how a red sky at dawn was a portent of foul weather to come, but for the most part everyone in those hardworking days had more immediate concerns. Water had to be hauled, cattle had to be brought to pastures for grazing and firewood needed splitting.

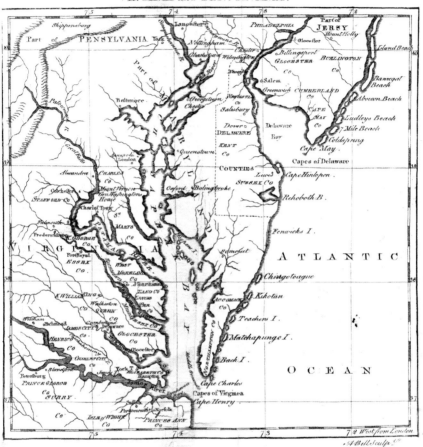

This 1781 map shows the entire Delmarva Peninsula that separates the Chesapeake and Delaware Bays. With so many low-lying coastal areas, the entire region is highly vulnerable to storms. *Courtesy Delaware Public Archives.*

Except for the very wealthy—of whom there were few in the Chesapeake—the simple labor of living was constant. Life wasn't easy, but the settlers were well aware that it could be worse. At least there was peace with the Nanticokes and the Susquehannocks, although wary Marylanders kept an eye on the settlers from the Virginia colony, who were constant rivals and no friends of Maryland's largely Catholic population. Settlers in the Chesapeake did not have to contend with wolves, bears or other dangerous predators, aside from the occasional fox in the henhouse.

The storm blew up quickly and with little warning. From the descriptions of the event and the autumn timing, it was almost certainly a hurricane. There was little or no understanding of the nature of storms in that era. The hurricane ravaged the Chesapeake Bay region and its hardscrabble settlers. "A mighty wind destroyed four-fifths of our tobacco and corn and blew down in two hours fifteen thousand houses in Virginia and Maryland," noted one account.

According to weather historians, this was one of the worst storms ever to reach our shores, and its impact was felt across the Chesapeake region at a time when the struggling population was especially vulnerable.

According to the National Oceanic and Atmospheric Administration (NOAA), the "great storm" first struck the northern Outer Banks of North Carolina and southeastern Virginia. The wind turned from the northeast to due south and finally to the west, which suggests a track similar to the August 1933 hurricane, a benchmark storm for the Hampton Roads area in the twentieth century. This 1667 hurricane lasted about twenty-four hours and was accompanied by savage winds and flood tides.

In addition to the widespread crop damage, thousands of houses and buildings were destroyed, which must have been almost total devastation considering the small population of the region. Cattle, horses and other livestock—not to mention people—drowned in the flooding brought on by torrential rains and a reported twelve-foot storm surge.

The system greatly impacted weather for days, much as a "modern" tropical storm system might. Reports say it brought twelve days of rain to Virginia, Maryland and beyond. Considering the length of the storm, however, weather historians speculate that a second hurricane or tropical storm system may have passed by close on the heels of the first, thus producing a period of extended rain.

This account of the Great Hurricane was published in London not long after the storm:

*Sir having this opportunity, I cannot but acquaint you with the relation of a very strange tempest which hath been in these parts (with us called a hurricane) which had began August 27th (September 6th Julian calendar) and continued with such violence, that it overturned many houses, burying in the ruines much goods and many people, beating to the ground such as were any wayes employed in the fields, blowing many cattle that were near the sea or rivers, into them, whereby unknown numbers have perished, to the great affliction of all people, few having escaped who have not suffered in*

*their persons or estates, much corn was blown away, and great quantities of tobacco have been lost, to the great damage of many, and utter undoing of others. Neither did it end here, but the trees were torn up by the roots, and in many places whole woods blown down so that they cannot go from plantation to plantation. The sea (by the violence of the wind) swelled twelve feet above its usual height drowning the whole country before it, with many of the inhabitants, their cattle and goods, the rest being forced to save themselves in the mountains nearest adjoining, while they were forced to remain many days together in great want. The tempest, for the time, was so furious, that it hath made a general desolation, overturning many plantations, so that there was nothing that could stand its fury.*

Another contemporary writer provided this account from Virginia:

*This poore country is now reduced to a very miserable condition by a continental course of misfortune. On the 27th of August followed the most dreadful Hurry Cane that ever the Colony groaned under. It lasted 24 hours, began at North East and went around northerly till it came to west and so it came to Southeast where it ceased. It was accompanied with a most violent rain but no thunder. The night of it was the most dismal time I ever knew or heard of, for the wind and rain raised so confused a noise, mixed with the continued cracks of failing houses…The waves were impetuously beaten against the shores and by that violence forced and as it were crowded into all creeks, rivers and bays to that prodigious height that it hazarded the drowning of many people who lived not in sight of the rivers, yet were then forced to climb to the top of their houses to keep themselves above water. The waves carried all the foundations of the Fort at Point Comfort into the river and most of furnished and garrison with it…but then morning came and the sun risen it would have comforted us after such a night, had it not lighted to us the ruins of our plantations, of which I think not one escaped. The nearest computation is at least 10,000 houses blown down, all the Indian grain laid flat on the ground, all the tobacco in the fields torn to pieces and most of that which was in the houses perished with them. The fences about the corn fields were either blown down or beaten to the ground by trees which fell upon them.*

The storm soon passed on toward Manhattan; early settlers there also recorded its devastating effects.

By all accounts, the Chesapeake region had suffered a "direct hit" in terms of a tropical hurricane. It must have been quite a storm to warrant reports in

the London newspapers, for the colonies were no stranger to severe weather. Then again, it had been nearly twenty years, and possibly more than three decades, since such a huge storm had struck the Chesapeake.

## BAY OF STORMS

The following compilation of New World hurricanes comes from a summary provided by NOAA. On June 23–26, 1586, the famous explorer Sir Francis Drake arrived near Roanoke Island, soon-to-be-infamous for its lost colony. It's somewhat ironic that he crossed the Atlantic only to be met by what was described as an "extraordinary" New World storm that came near to destroying the Englishman's fleet. His flagship, *Primrose*, dragged free despite its 250-pound anchor. Hail the size of hen's eggs battered the Virginia explorers. They were also treated to the sight of waterspouts spinning dangerously and wildly nearby. The storm caused a great deal of damage to the fledgling colony and Drake's fleet. Disheartened, the surviving settlers soon went home to England.

Just over one year later, in August 1587, Drake experienced another hurricane at Roanoke. Drake decided that the best course of survival for his ships lay in making a run for the open ocean rather than having his fleet battered to pieces in the shallows. It reportedly took six days for the surviving ships to find one another, so badly had they been scattered by the hurricane winds.

Another severe hurricane struck Roanoke on August 26, 1591. Descriptions say the northeast winds blew into the harbor, causing huge waves and dangerous currents. And then came a relative lull in the major storms to strike the early colonists. Then, in 1649, a "great storm and tide" was described as striking the Chesapeake region. The devastating 1667 storm already described here wiped out thousands of houses. Smaller storms came in 1669 and again in 1683.

On October 29, 1693, came a "most violent storm" that experts say changed the course of several navigation channels and created new ones up and down the East Coast. The storm rolled across the Delmarva Peninsula, leaving flooding and downed trees, plus ruined houses and barns, in its wake.

With such a history of storms, it's almost a wonder that colonists didn't give up on the region. But they were a hardy bunch, not willing to abandon their dreams of freedom and wealth because of occasional storms—which were widely spaced enough that residents might hope

each had somehow been the last big one. They dried out, rebuilt and went on with their lives.

Again and again, this would be the story of extreme weather in the Chesapeake. Storms battered the residents, but they would pick up the pieces and go on. The smaller storms have since blended into the fabric of history, but some have lived on in memory and imagination to become the stuff of Chesapeake Bay legend.

# GEORGE WASHINGTON'S STORM

## THE GREAT CHESAPEAKE BAY HURRICANE OF 1788

*The wind that blows*
*Is all that anybody knows*
—*Henry David Thoreau, Concord Journal*

George Washington led the Continental army through the Revolutionary War and the nation through its earliest days, but before he became a Founding Father, Washington was first and foremost a farmer. And like any good farmer, he kept an eye on the weather that affected his vast estate at Mount Vernon, Virginia. The mansion overlooks the Potomac River, not far from Chesapeake Bay. While majestic, the view also left Washington's home vulnerable to the Chesapeake's fiercest storm—the hurricane.

On July 19, 1788, a storm began forming near Bermuda that would become known as "George Washington's Storm" for the detailed account that he kept of the storm. From Washington's journal, we know that the eye of the hurricane passed directly over Mount Vernon.

A little after midnight on July 23, the storm pounced upon the Chesapeake region and "blew a perfect hurricane, tearing down chimneys, fences, etc." Accounts say the winds felled large trees, leveled crops and even shifted houses off their foundations.

A storm like that coming at harvest time was devastating to the farms and orchards of the region. Trees heavy with fruit were blown down or their weighted limbs snapped. Corn was flattened, and the last of kitchen gardens was shredded.

The storm was just as bad on the water. Ships of all sizes that attempted to ride out the storm sank or were pounded to splinters at their moorings.

Located in a rural churchyard on the Eastern Shore is the grave of Captain John Lovering, a sea captain who died in September 1754. Thousands of other mariners and passengers were lost at sea during the 1700s and 1800s. The headstone is notable for the unusual skull and "batwings" decorating it. *Author's photo.*

In Portsmouth, Virginia, accounts say a large ship was floated by the storm surge into the center of town.

As always, Washington was focused not only on observation but also on the impact the storm would have on the roughly eight thousand acres he owned surrounding his home. On July 24, he wrote:

> *Thermometer at 70 in the morning, 71 at noon and 74 at night. A very high N.E. wind all night which this morning being accompanied with rain became a hurricane driving the miniature ship* Federalist *from her moorings and sinking her; blowing down some trees in the groves and about the houses, loosening the roots & forcing many others to yield and dismantling most in a greater or lesser degree of their Bows, and doing other and great mischief to the grain, grass &c. and not a little to my mill race; in a word it was violent and severe more so than has happened for many years. About noon the wind suddenly shifted from N.E. to S.W. and blew the remaining part of the day as violently from that quarter. The tide about this time rose near or quite 4 feet higher than it was ever known to do driving Boats &c. into fields where no tide had ever been heard of before, and must it is apprehended have done infinite damage on their Wharves at Alexandria, Norfolk, Baltimore &c.*

According to weather records, the 1788 hurricane followed a path—and shared an intensity—very similar to the 1933 storm that would carve Ocean City's inlet. This path makes "George Washington's Storm" one of the more memorable storms on Chesapeake Bay—and we have the Founding Father himself to thank in part for keeping good records of the storm.

# BALTIMORE VERSUS CHARLESTOWN

## The Hurricane that Sealed a Town's Fate

*Above, the vast remoteness of the sky*
*Proves this is a world where loneliness is king.*
*—Gilbert Byron*

Digging through files of old photographs in search of images to illustrate this book, I came across one that seems particularly forlorn. It shows a dusty street in a rural town, with pigs rooting in the wagon tracks. Three women standing at the edge of the street—as if to avoid the traffic that never comes—only accentuate the overall feeling of loneliness in this photograph of the town of Charlestown in the late 1800s. From the leaves on the trees and height of the roadside weeds, it appears to be late spring or summer, and one can almost hear the insects buzzing in the heat.

It was possible, even then, that someone remembered the dream that had once been Charlestown's—and how life in Charlestown had turned out to be very different from what its planners foresaw for its future. Laid out in 1742, the village located at the top of the Chesapeake Bay is one of Maryland's older towns. A map of Charlestown shows a carefully planned town laid out in a grid pattern with more than three hundred lots and space reserved along the Northeast River waterfront for wharves and storehouses. Four lots were reserved for the county courthouse established there. There was a spacious town green akin to those in New England towns where militia could drill and sheep could graze. Like any ambitious town of its day, Charlestown was named in honor of the Lords Proprietor of Maryland, in this case Charles Calvert, fifth Lord Baltimore.

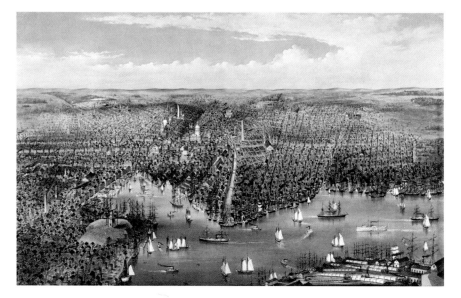

An 1850 Currier & Ives illustration of Baltimore. The city was very much a waterfront town, welcoming ships from around the world, as well as Chesapeake Bay steamers and the oyster fleet. *Courtesy Library of Congress.*

There were high hopes for Charlestown when those plans were drawn. The town was located at the very top of the Chesapeake Bay, as far north as one could travel by water. Passengers and goods could then travel by land to Philadelphia or New Castle, Delaware, on the Delaware Bay. It was an ideal location to take advantage of this process of eighteenth-century travel in the days before canals or railroads. It also helped that Charlestown was only a short wagon trip to the booming grain fields of northern Maryland and southern Pennsylvania. Grain loaded in Charlestown could be shipped to Europe and, thus, increase the wealth of ship owners and farmers alike. Investors flocked to Charlestown in those heady days to build grand houses and taverns, wharves and warehouses. The town seemed poised to become Chesapeake Bay's key port.

According to *At the Head of the Bay: A Cultural and Architectural History of Cecil County, Maryland*, Charlestown exported grain and salted fish (mainly herring and shad) to the West Indies. Ships then returned with rum, sugar, slaves and immigrants to the colonies. These and other men built homes in Charlestown. There is the 1745 Hamilton House on Lot 74, named after the Reverend John Hamilton—who apparently bought the house as a safe investment in an up-and-coming town—and the Tory House built in 1750. One of the more curious houses is the Still House, circa 1760, where raw

Charlestown once competed with Baltimore to be Chesapeake Bay's leading port city, but by the time this photo was taken in the late 1800s, it was only a sleepy town with hogs roaming the dirt streets. A hurricane in the mid-1700s silted in the upper Chesapeake Bay, dashing the town's economic hopes as commerce moved to Baltimore. *Courtesy Historical Society of Cecil County.*

sugar from the West Indies was made into rum. At the time, it was the only rum distillery in the region, and Charlestown became known for both serving and drinking rum. As many as ten taverns and inns operated in Charlestown at the height of its boom.

Charlestown's chief rival was Baltimore, founded in 1729 and named in honor of Cecilius Calvert, then the reigning Lord Baltimore. Baltimore's success as a port was not a foregone conclusion. Although it was larger than Charlestown, the booming port in Cecil County might have outstripped the town on the Patapsco River. Like Charlestown, Baltimore was primarily intended as a port for the export of grain. While Baltimore had much to recommend it and its own set of boosters, Charlestown had its own prominent investors.

Several prominent businessmen shared the same vision for Charlestown's future. They built fine houses on the clustered streets, creating an urban environment on the edge of farm country. Ships came and went. Among the early settlers and promoters of Charlestown were John Paca, father of

Declaration of Independence signer and future Maryland governor William Paca; Francis Scott Key's grandfather, Francis Key; Governor Thomas Bladen; and Revolutionary War hero and congressman Nathaniel Ramsey. Like the good businessmen that they were, these men hoped to be on the ground floor of Charlestown's growth years as an important port.

There's an old saying that if you wish to make God laugh, tell him about the plans you made. Years later, Charlestown's planners could shake their heads wistfully at how Mother Nature had made a folly of their own ambitious plans.

That twist of fate came in the form of a Chesapeake Bay hurricane. There is some debate about which hurricane struck Charlestown—and when. The date of 1786 is often given, but records show no hurricanes for that year. Instead, it was most likely the Great Chesapeake Bay Hurricane of 1769 that caused Charlestown irreparable harm, with tidal surges up to twelve feet. Anyone who has lived on Delmarva for any length of time knows that these storms can wreak terrible havoc. The same was certainly true for Charlestown. Along with high winds, rain and flooding, this storm brought flood tides and savage currents that altered a waterway. When the storm subsided, Charlestown's once-booming port was badly silted in, taking away its deep-water access for the grandest wooden sailing ships.

Hurricane seasons tend to run in cycles, and the mid-1700s were a time of unusual hurricane activity. Charlestown felt the impact of several hurricanes and tropical storms, including major hurricanes in October 1743 and October 1749, the aforementioned 1769 storm, the "Hurricane of Independence" in 1775 and hurricanes that struck the Chesapeake again and again in 1780, 1785, 1788 and 1795. Ultimately, it may not have been one storm but a series of hurricanes that sealed the town's fate.

To Charlestown's investors and planners, it must all have seemed like a cruel joke. Each storm filled the channel leading to the town's wharves with yet more silt. In those pre-industrial days, there was no hope of dredging the waterways. The town found itself surrounded by increasingly shallow waters.

To the south, Baltimore had been spared the same fate. The storms that had been so cruel to the upper bay seemed to spare the growing town on the Patapsco, which was much farther from land access to Philadelphia but blessed with a deeper channel to the sea.

By 1790, Baltimore's population had reached 13,503. By its heyday in the post–World War II era as a shipping and steel-producing center, Baltimore had more than 1 million residents. (Charlestown's population is now just over 1,000—roughly what it may have been in the late 1700s.)

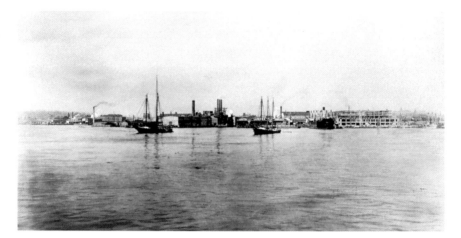

Baltimore Harbor shown in 1913. Sailing ships are anchored farther out, while a barge and ship appear to be docked at the Canton Lumber Company wharf. *Courtesy Library of Congress.*

The town that had been up-and-coming gradually became a backwater. Ships sought other ports. The inns closed, and the famous distillery was dismantled. Even the Cecil County Courthouse left for the faster-growing town of Elkton, which became the county seat of commerce. Some pragmatic merchants packed up and moved to Baltimore, literally taking apart their dwellings and storehouses and then re-erecting them in the town that was once Charlestown's rival. In what may have been the ultimate indignity, the man who had been one of Charlestown's biggest backers, Nathaniel Ramsey, became chief officer of the Port of Baltimore in 1794.

Charlestown never really died away, but neither did it thrive. In the late 1700s, one smug critic had scoffed, "What, I beseech you, is Charles town?—a deserted village, with a few miserable huts thinly scattered among the bushes and crumbling into ruin." The town fathers were called upon to take action when its empty streets became home to a version of urban bowling played with cannonballs by young swells. A new law put an end to the practice of pitching the cannonballs down the streets, much to the relief of passing horses and the handful of pedestrians. In the sleepy town, the controversy caused scandalous excitement and much discussion.

And some years later, that photograph I came across was taken. The weedy streets were all that remained of Charlestown's storm-battered dreams. While today it is a lovely small town with a million-dollar view of the upper Chesapeake Bay, its hopes of being Maryland's port city are but a dimly recalled memory.

# PART II

# THE 1800s

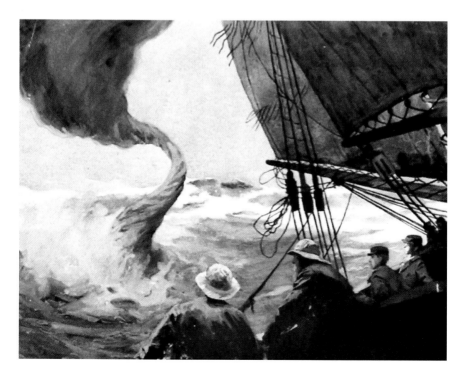

Sailors look on in this nineteenth-century magazine illustration as a waterspout approaches their sailing vessel. *Courtesy Library of Congress.*

# FIRE AND NATURE'S FURY DURING THE WAR OF 1812

*Summer grass—*
*All that's left*
*Of warrior's dreams.*
*—Basho*

O ne of the great weather legends comes from the War of 1812 and a sad chapter in United States history, the capture and burning of Washington by British forces in August 1814. The weather, as we shall see, played a pivotal role in more ways than one.

In 1814, Washington, D.C., was barely more than a frontier town. Carved out of the swampy wilderness along the Potomac River in the late 1700s, the layout of the new capital's streets had been designed by French architect Pierre L'Enfant. Considering that many American towns and cities had sprung up almost by happenstance, the opportunity to actually plan the construction of the city was unique. L'Enfant designed the city with defense in mind. Rather than being built on a grid pattern, the streets radiated from several central circles almost like the spokes of a wheel. This unique design enabled an artillery unit placed in one of these circles to open fire on an attacker approaching from any direction. Thus, a relatively small force could defend the city. It was a brilliant defensive plan but one that was never utilized.

In that new seat of government, amenities and niceties were so few that visitors from the great cities of Europe were either appalled or amused. With its unpaved streets and generally swampy location, it was also a city easily impacted by the weather. Grand as the avenues were in L'Enfant's

plans, in reality they were vast muddy stretches where pigs snuffled in the autumn mud and chickens scratched in the summer dust. Government officials and congressmen traveling between the White House and Capitol encountered brush growing in the middle reaches of Pennsylvania Avenue. Mud was a constant problem for much of the year. Legislators from New England complained about the muggy summer weather. In those days before window screens, residents swatted at clouds of mosquitoes that blew in from the marshy areas along the Potomac River. Slaves labored in the heat. The public buildings were large, marble and ornate, but they arose out of weedy surroundings. As a nation, the United States had not yet grown into its capital city.

The most magnificent building was the Capitol, designed by Benjamin Latrobe. However, it was very different from the building Americans know today because it lacked the dome completed during Abraham Lincoln's presidency. The Senate and House chambers were linked by a wooden passageway. The chamber of the House of Representatives was octagonal and measured eighty-five feet by sixty feet. Massive columns upheld a wooden roof with one hundred skylights made of imported English glass.

Americans took great pride in the Library of Congress building. The main room measured eighty-six feet by thirty-five feet, and the ceiling reached thirty-six feet. The library contained nearly three thousand books. Many of the books had been printed in London, their pages filled with English history and explanations of English law.

Washington had symbolic value, but it was not a city of real strategic importance. There was a navy yard, but otherwise the city had no military base or any real commerce or industry. It was a city created as a seat of government rather than commerce. By comparison, nearby Baltimore was a thriving commercial center with a busy port where goods arrived from around the world. Baltimore's privateers were a thorn in the side of both the Royal Navy and the British merchant fleet.

Washington's lack of strategic value lulled the nation's leaders into a false sense of security during the War of 1812. The common logic was that the British would not bother to attack Washington but would target Baltimore instead. Some politicians insisted on this viewpoint right up until the redcoats were at the very gates.

Leading the British troops were two very capable commanders, Royal Navy admiral George Cockburn and Army general Sir Robert Ross. Ross, a hero of the Napoleonic Wars, was in overall command of the expedition. Cockburn wasn't about to miss the adventure and joined the land expedition.

In what was a typical attack strategy during the War of 1812, British forces approached from two directions. By water, the British sailed up the Potomac River. They were amazed to discover that Fort Washington, guarding the approach to the city, had been abandoned. Unopposed, the British sailed on to Alexandria, where the city fathers surrendered to avoid any burning and pillaging. On land, the second part of the British force marched toward Washington. Ross moved cautiously, amazed that his troops were crossing enemy territory almost unopposed. He did not, however, let down his guard as his army moved deeper into Maryland.

Historians speculate that the Americans were too intent on guarding Baltimore—which would come under attack two weeks later and lead to a rather famous flag and song. The British move against the nation's capital was unexpected. A hasty, last-minute attempt at defending the city became a case of too little, too late. Experienced fighters from the rank and file suggested that the Americans harry the British relentlessly, felling trees across the roads and ambushing the redcoats at every opportunity. This strategy had worked well enough during the Revolutionary War. The American leadership preferred to meet and defeat the British on more equal terms on a battlefield.

For the British, the biggest enemy was not the local militia but the Chesapeake Bay's notoriously steamy August weather. Most of the troops had been aboard ship for months and were in poor physical condition for marching down the sun-baked roads. Burdened with wool uniforms, muskets and packs, soldiers collapsed in the heat and died of sunstroke. The humid summer weather claimed more lives than American bullets or bayonets. The storm that was soon to come would take an even greater toll.

British troops finally encountered American militia at the village of Bladensburg outside Washington. Americans forces outnumbered the British, but once again the militia was no match for seasoned redcoats.

President James Madison had ridden out from the White House to inspire the troops defending the city. Before the battle began, Madison galloped toward the bridge leading into Bladensburg, a pair of dueling pistols flapping in the holsters he had tied to his waist. Alarmed, an officer ran out just in time to warn the president that the British already occupied the town. One can only imagine the embarrassing consequences if the British had captured the president.

The battle began before either side was ready to fight. Skirmishers opened fire, the distant pop, pop, pop of muskets carrying across the hot, still countryside. The redcoats charged right at the American lines. The

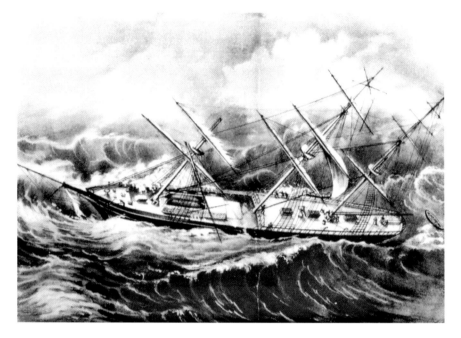

A ship struggles for survival in this nineteenth-century illustration. Before modern communication, friends and family waited anxiously on shore for the arrival of a ship after a storm had passed at sea. As part of a recent United States maritime exhibit, officials at the Smithsonian estimated that between 1800 and 1850, several thousand Americans and immigrants on their way to America lost their lives in disasters at sea. *Courtesy Library of Congress.*

sight of bayonets gleaming in the sun was too much for the American militia, which fled so quickly that the battle would come to be nicknamed "the Bladensburg races."

All opposition swept aside, the British marched on toward the American capital. At the White House, with the president away at the battlefield, First Lady Dolley Madison packed what valuables she could. The air was remarkably steamy and oppressive, hindering her efforts. She ordered the full-length portrait of George Washington cut from its frame and saved from the invaders. Mrs. Madison dashed off a letter to her sister: "I have pressed as many Cabinet papers into trunks as to fill one carriage," she wrote. "Our private property must be sacrificed, as it is impossible to procure wagons for its transportation." She then fled with the wagon and a small group of servants. In the distance, she could hear the rumble of artillery like summer thunder.

The redcoats were in Washington by 8:00 p.m. They found a city that was all but abandoned. A few American thieves were already busy looting the empty homes of the wealthy. Cockburn ordered his marines to break down

the doors of the United States House of Representatives. The admiral and his men then wandered around the House chamber, admiring the ornate surroundings. Cockburn plunked himself down in the speaker's chair and called out, "Shall this harbor of Yankee democracy be burned? All for it will say 'aye!'" His men gave a cheer and then began piling furniture for the bonfire. Flames soon spread through the House and Senate.

The British then moved on to the deserted president's house, the contents of which became spoils of war. The invaders found the dining room set for what was to have been the president's victory feast. The redcoats helped themselves to the food and wine, drinking to the health of the king. Admiral Cockburn took a cushion from Dolley Madison's chair as a keepsake, crudely joking about possessing the first lady's "seat." Dinner over, they set the president's house on fire.

Soon the White House, Capitol and Library of Congress were burning, along with other public buildings. The flames were visible from as far away as Baltimore, where the residents worried that they might be next. More buildings were burned the next day, including the War Department and offices of the secretary of state. Private homes and factories also were put to the torch. There was a great deal of looting, both by British troops and unsavory Americans who lurked in the ruins. Damage was estimated at more than $2 million at that time, an almost incalculable amount in today's dollars.

In his *History of Maryland: 1812–1880*, published in 1879, John Thomas Scharf quotes British officer George Gleig when he writes:

*"I have stated above," says the English chronicler, "that our troops were this day kept as much together as possible upon the Capitol Hill. But it was not alone on account of the completion of their destructive labors, that this was done. A powerful army of Americans already began to show themselves upon some heights, at the distance of two or three miles from the city; and as they sent out detachments of horse, even to the very suburbs, for the purpose of watching our motions, it would have been unsafe to permit more straggling than was absolutely necessary. The army which we had overthrown the day before, though defeated, was far from annihilated; and having by this time recovered its panic, began to concentrate itself on our front, and presented quite as formidable an appearance as ever. We learnt, also, that it was joined by a considerable force from the back settlements, which had arrived too late to take part in the action, and the report was, that both combined, amounted to nearly twelve thousand men."*

As the British occupied the ruined city and anxiously watched the American forces gathering, the sky suddenly darkened soon after the noon hour. Without any real warning, the storm rolled in off Chesapeake Bay and struck the city with tremendous force. According to Scharf's account, the British officer recalled:

*The sky grew suddenly dark, and the most tremendous hurricane ever remembered by the oldest inhabitant in the place, came on. Of the prodigious force of the wind, it is impossible for you to form any conception. Roofs of houses were torn off by it, and whisked into the air like sheets of paper; while the rain which accompanied it, resembled the rushing of a mighty cataract, rather than the dropping of a shower. The darkness was as great as if the sun had long set, and the last remains of twilight had come on, occasionally relieved by flashes of vivid lightning streaming through it, which, together with the noise of the wind and the thunder, the crash of falling buildings, and the tearing of roofs as they were stript from the walls, produced the most appalling effect I ever have, and probably ever shall witness.*

*This lasted for nearly two hours without intermission; during which time, many of the houses spared by us, were blown down, and thirty of our men, besides several of the inhabitants, buried beneath their ruins. Our column was as completely dispersed, as if it had received a total defeat; some of the men flying for shelter behind walls and buildings, and others falling flat upon the ground to prevent themselves from being carried away by the tempest; nay, such was the violence of the wind, that two pieces of cannon which stood upon the eminence, were fairly lifted from the ground and borne several yards to the rear.*

The winds, rain and lightning seemed like some awful reckoning. Gusts blew so hard that marauding redcoats were knocked off their feet. More bad luck befell the British when a well packed with captured American gunpowder exploded, killing thirty men and wounding forty-seven.

Several contemporary accounts describe the event as a "hurricane," but the term was sometimes used in a more general way than it is today. In our more advanced age of weather forecasting, the term "hurricane" has a more specific meaning than it did in 1814, when the term may have defined a really windy storm.

Could it have been a Chesapeake Bay hurricane or its first cousin, a tropical storm? The storm came without any real warning, preceded by a period of

hot, muggy weather. It blew itself out after about two hours of intense wind and rain. While summer storms can be amazingly intense, it's unlikely that one of the Chesapeake region's notorious summer squalls lasted two hours. That time frame would be just about right for a fast-moving hurricane or tropical storm.

In any case, it might not matter all that much whether the storm was a hurricane. It must have seemed like a portent to the British, who had just invaded and burned the American capital. It might have seemed like some punishment sent from heaven above. For the American government forced into exile, and those militia who had left home to defend against the invaders, the storm must have felt like misery. Rain extinguished the smoldering ruins of the city.

Ultimately, as described in the account, the storm helped save lives by preventing a second battle from taking place. In Scharf's pages, the British chronicler George Gleig continued: "When the hurricane had blown over, the camp of the Americans appeared to be in as great a state of confusion as our own; nor could either party recover themselves sufficiently, during the rest of the day, to try the fortune of a battle."

On Thursday night, the British moved out. General Ross was reluctant to spend another night in the burned ruins of Washington. His small force, battered by the elements, was in hostile territory. He knew that if the American militia managed to organize an attack, the redcoats might face disaster. The British returned to their waiting ships under cover of darkness and with great stealth. Gleig wrote:

> It being matter of great importance to deceive the enemy, and to prevent pursuit, the rear of the column did not quit its ground upon the capital till a late hour. During the day an order had been issued that none of the inhabitants should be seen in the streets after eight o'clock; and as fear renders most men obedient, this order was punctually attended to. All the horses belonging to different officers had likewise been removed to drag the guns; nor was any one allowed to ride, lest a neigh, or even the trampling of hoofs, should excite suspicion. The fires were trimmed, and made to blaze bright, and fuel enough left to keep them so for some hours; and finally, about half-past nine o'clock, the troops formed in marching order, and moved off in the most profound silence. Not a word was spoken, nor a single individual permitted to step one inch out of his place; and thus they passed along the streets perfectly unnoticed, and cleared the town without any incident.

In the Montgomery County village of Brookeville, President Madison was settling into his temporary headquarters. Madison stayed at the home of the town postmaster, Caleb Bentley. Members of his cabinet found lodging at other houses in town. The United States government had reached its most vulnerable moment, yet it somehow managed to endure and function out of the postmaster's house.

Returning to the city burned by the British and then battered by the storm was heartbreaking for most residents. "I cannot tell you what I felt on re-entering it," Dolley Madison sadly recalled upon reaching the city, now doubly damaged by fire and wind. "Such destruction—such confusion."

# THE GREAT ICE BRIDGE OF 1852

*Winter solitude*
*In a world of one color,*
*The sound of wind.*
*—Basho*

One of the most beautiful times in the Chesapeake region comes when the seasons change. Many others have written wonderful descriptions of the Chesapeake Bay's weather and the changing seasons. There is something poetic about this shift in the seasons, from the way that the light fades and goes rose soft at twilight late in the fall to the first sounds of the peeper frogs in the early spring. While its storms can be fierce, it's the changing seasons that help give the Chesapeake Bay its charm. Of all the seasons, however, winter may be the most unwelcome.

Winter can be a hard and cruel season, but it's not without its own terrible beauty. In *Beautiful Swimmers: Watermen, Crabs and the Chesapeake Bay*, William Warner describes the first signs of winter on the Chesapeake:

> *It can come anytime from the last week in October to the first in December. There will be a fickle day, unseasonably warm, during which two or three minor rain squalls blow across the Bay. The sun appears fitfully in between; sometimes there is distant thunder. A front is passing. The first warning that it is more than an ordinary autumnal leaf chase comes near the end. The ragged trailing edge of a normal front is nowhere to be seen.*

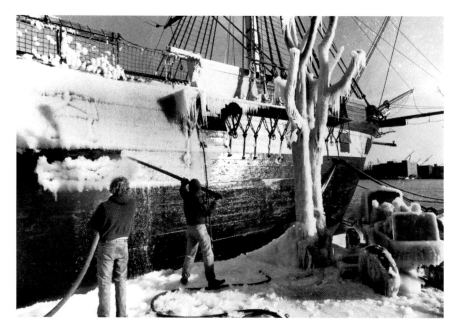

Volunteers chip layers of ice off the USS *Constellation* following a January 1972 winter deep freeze at Baltimore's Inner Harbor. Baltimore Sun *photo by George H. Cook. Used by permission.*

*...Then it comes. The wind rises in a few minutes from a placid five or ten knots to a sustained thirty or forty, veering quickly first to the west and then to the northwest. The dry gale has begun. Short and steep seas, so characteristic of the Chesapeake, rise up from nowhere to trip small boats. Inattentive yachtsmen will lose sail and have the fright of their lives. Workboat captains not already home will make for any port...Autumn, a charmingly indecisive time on the Chesapeake, has given way to winter.*

Winter storms in the Chesapeake region can be furious, pounding the woods, fields, water and roads with wind and snow. And then there is the cold, so intense that summer seems like a fool's dream.

In the seventeenth and into the eighteenth centuries, the Chesapeake region was experiencing what we now call the Little Ice Age, which brought on cool summers and rough winters. The winters of 1635 and 1741—when the bay froze its entire length—were notable historically. One of the coldest East Coast winters was likely in 1779–80. In Manhattan on the morning of January 29, at British headquarters, an officer recorded a temperature of minus sixteen degrees. One can only imagine how the soldiers of both sides

in the American Revolution must have suffered from the elements in an era without fleece, knit caps and the most basic gloves and mittens. That winter was so long and cold that the Delaware Bay remained icebound until March.

On the Chesapeake Bay, the ice stretched to the mouth of the Potomac, a reported six inches thick. The ice remained thick and solid from Baltimore and Annapolis to Kent Island for weeks on end. Contemporary accounts describe how horse-drawn carts crossed the ice in the area now spanned by the Chesapeake Bay Bridge.

In 1784, the architect Joseph Clark, who designed the beautiful Maryland statehouse dome at Annapolis, skated there from Baltimore on the frozen Chesapeake. It was another particularly cold winter, and Baltimore harbor was closed until March 19. Mr. Clark wasn't the only one to make the trip. The *Niles Weekly Register* described how, during January, Joshua H. Valliant and George W. Hynson skated from Baltimore to Annapolis—a distance of thirty miles—in three and a half hours and then turned around and skated home again the same day.

While a trip across the ice must have been novel and exciting to those travelers, there were times when it could have deadly consequences. On February 5, during the record cold winter of 1780 near Lancaster, Pennsylvania, a terrible tragedy was recorded in the diary of Thomas Hughes. He described how forty people in a wedding party set out for a sleigh ride on the frozen Susquehanna River. Their sleighs broke through the ice, and thirty-six drowned, including the newlyweds.

Travelers had to endure great hardship even as the era of railroads began. Newspaper accounts describe how children sold hot bricks to passengers on the trains. One of the great weak links in train travel was the lack of a bridge across the Susquehanna River. At that time, in the early days of train travel between New York, Philadelphia and Baltimore, no bridge spanned the river. Passengers were required to disembark at Perryville on the northern shore and then take a ferry to Havre de Grace on the southern shore of the river. From there, they again boarded a train and rode down to Baltimore.

The transfer was time consuming even when things went smoothly. Often, the weather didn't cooperate. During harsh winters, the Susquehanna would freeze or become filled with huge ice rafts, making it impossible for the ferry to operate. Train travel came to a standstill up and down the East Coast. For many years, there was talk of building a bridge across the Susquehanna. In November 1833, the *Niles Weekly Register* reported, "A reconnaissance of a railroad from Baltimore to Port Deposit is now making, with the view to a continuous line of railroads between Baltimore and Philadelphia—a

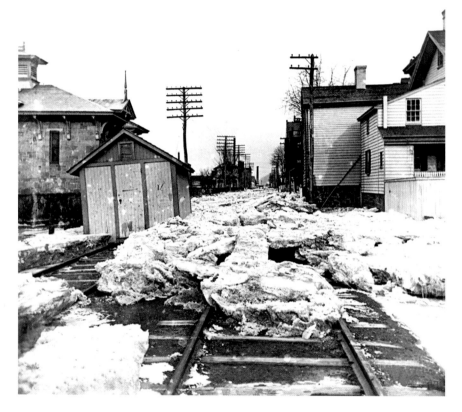

Ice covers the tracks of the Port Deposit–Columbia Branch of the Pennsylvania Railroad after a 1904 "ice gorge" in the river town. *Courtesy Historical Society of Cecil County.*

considerable part of the present road being almost impassable at certain season of the year, when the navigation is obstructed by ice."

Yet nothing was done, and the outbreak of the Civil War would continue to delay construction. Until then, winter storms and cold spells remained an obstacle to travel and the United States government itself. On February 23, 1856, the postmaster general of the United States, James Campbell, was called before the Senate to explain why the mail wasn't getting through to Washington from northern cities:

> *Sir: In obedience to the resolution of the Senate, of 19th instant, concerning the frequent failures of the northern mail in its transmission to this city, I have the honor to submit the following statement:*
>
> *On fourteen days of January and four of the present month, up to 19th, the mails failed to reach Philadelphia from New York in time to connect*

*with the cars for Baltimore, owing to the obstructions on the railroad caused by snow storms, ice, and other incidents of the extreme cold weather. At times the snow drifts were impassable, and on several days the cold was so intense as to freeze the pumps of the engines. During the same period only four failures occurred from other causes.*

# THE GREAT ICE BRIDGE

Perhaps one of the most unusual incidents related to winter weather concerns the Great Ice Bridge across the Susquehanna River. Winter struck hard and cold on the Chesapeake in 1852, and the Susquehanna froze solid. The ferry could not cross, and travel again stopped from north to south.

But not for long. Industrious and adventurous railroaders laid tracks across the ice so that the train could travel all the way across. The Great Ice Bridge was such a novelty that it was reported on extensively in its day. The following are detailed accounts from contemporary newspapers and magazines.

An 1856 excerpt from the *Philadelphia, Wilmington and Baltimore Railroad Guide*:

*The ice in the river offered so insurmountable an obstacle to its passage by any ordinary means, that it was determined to lay a track upon it. This was completed on the 15th day of January, and continued in use until February 24th, when it was taken up, and, in a few days, the river was free of ice. During this time, 1,378 cars loaded with mails, baggage and*

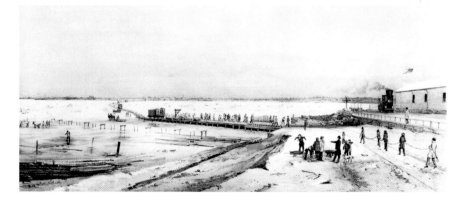

This magazine image shows the ice bridge used to cross the frozen Susquehanna River during the bitter winter of 1852. *Courtesy Historical Society of Cecil County.*

*freight were transported upon this natural bridge, the tonnage amounting to about 10,000 tons. The whole was accomplished without accident of any kind; and the materials were all removed prior to the breaking up of the river without the loss of a cross-tie or bar of iron.*

A highly detailed account in sometimes purple-tinged prose comes courtesy of an 1852 edition of the *Mechanics' Magazine and Journal of Science, Arts, and Manufactures*:

*The engineer of the railway* [saw] *his ferry line at Havre de Grace cut off, and the river filled almost to the bottom with a vast accumulation of cakes of ice, a foot thick, edged up, and frozen in that position, so as to present a mass of great strength, but most forbidding superficial aspect.*

*Contemplating this with the true eye of science, and seeing its adaptation to his purpose, Mr. Trimble, the Engineer of the Railroad Company, determined to form over this rude glacier a railroad for his baggage and freight cars, and a sledge road alongside of it, upon which two-horse sleighs could carry his passengers, and by means of towing lines, propel the freight cars over the river. This was the great idea, and most promptly and successfully has it been carried out.*

*The first step was to locate the railroad; for upon this rough surface of ice, a straight line between the ferry landings, would have required too much graduation,—too much excavation and embankment, so to speak, of ice and snow.*

*The line was accordingly staked out with several curves, so as to reduce the labour required in grading the frozen surface; the projections, points, and ridges were cut away, and broken fragments of ice were used to fill up the hollows. Then upon condemned ties about four feet apart, with some new timber interspersed, a track was laid with U rails, of about 40 lbs. to the yard, confined merely by hook-headed spikes, and without chairs.*

*…Forty freight cars per day, laden with valuable merchandise, have been worked over this novel tract by the means above referred to, and were propelled across the ice portion by two-horse sleds running upon the sledge road, and drawing the cars by a lateral towing line, of the size of a man's finger.*

*At the present writing, this novel and effectual means of maintaining the communication at Havre de Grace is still in successful operation, and will so continue until the ice in the river is about to break up. Then, by means of the sledges, the rails (the only valuable part of the track), can be rapidly*

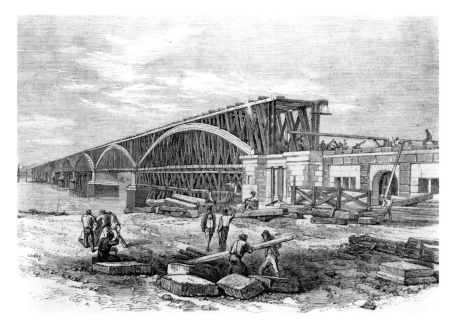

This magazine illustration shows construction of the bridge spanning the Susquehanna River between Perryville and Havre de Grace in Maryland. The bridge was a crucial step toward overcoming weather woes for train travelers. Until the bridge was built, passengers had to catch a ferry across the river before continuing on by rail to Baltimore and Washington, D.C. *Courtesy Historical Society of Cecil County.*

*moved off by horse power, not probably requiring more than a few hours' time, so that the communication may be maintained successfully until the last moment. If properly timed, as it doubtless will be, the railroad may be removed, the ice may run out, and the ferry be resumed, it may be, in less than forty-eight hours.*

When a bridge was finally built in 1866, what a wonder it must have seemed to travelers—and probably a great relief to the postmaster general. Winter had been thwarted at last.

# FLASH FLOOD
# ON THE PATAPSCO

*I am there in the shining of water*
*Like dark, like light, out of Heaven.*
*—James Dickey, "In the Mountain Tent"*

One of the most devastating floods ever to strike the Chesapeake Bay region took place on the morning of July 24, 1868. Before the day was over, downtown Baltimore and Ellicott's Mills (today known as Ellicott City) would be badly damaged, with bridges and houses swept away. As many as fifty lives would be lost. And yet not a drop of rain fell before the flood struck.

The cause of the flood remains something of a mystery today, though there is little doubt that a tremendous storm was taking place to the west of the city. Residents of the mill town of Ellicott City on the Patapsco River described how a strange darkness seemed to fall across the Patapsco Valley. Flashes of lightning punctuated the darkness, though the storm was so far off that thunder couldn't be heard. So the people of Ellicott's Mills and Baltimore went about their business, keeping an eye on the weather.

Baltimore at that time was a major city, while Ellicott's Mills was a busy up-and-coming industrial center located fifteen miles upriver. The Patapsco was only navigable to Elkridge just a few miles downstream, so Ellicott's Mills was not a port town. Instead, Ellicott's Mills had become an important railroad town for the Baltimore & Ohio Railroad. The tracks followed the Patapsco River west through the narrow river valley toward Frederick and then the Appalachian Mountains beyond, linking east to west. In fact, the town had

been the setting for the famous race in 1830 between the original Tom Thumb steam engine and a horse-drawn rail car. (The horse won the race.)

Vessels could not navigate the river at that point because it was too shallow, but the town did rely heavily on the river to power several flour and cotton mills. The mills employed hundreds of workers, many of whom lived in cottages and row houses within a stone's throw of the river.

According to an account in *The River of History*, "At approximately 9:15 a.m., the westbound mail train steamed slowly from the railroad station and disappeared into an almost eerie darkness which had crept almost unnoticed eastward through the River Valley. The darkness intensified, interrupted by brilliant flashes of lightning illuminating the stone mills and houses lining the river's edge." According to witnesses, it became so dark that the millworkers had to stop work. Birds stopped singing.

The strange gloom and silence was like a warning. By 9:30 a.m., the Patapsco River had silently risen nearly ten feet. And then a terrible roaring

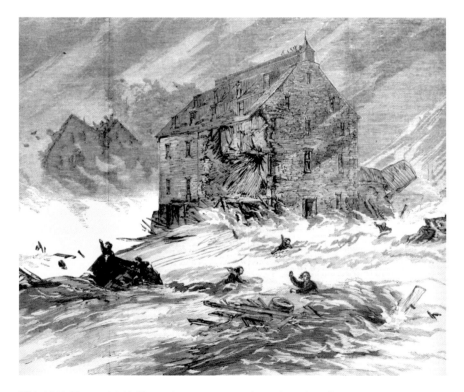

This 1868 *Harper's Weekly* illustration captures the fury of the flash flood that struck Ellicott's Mills on the Patapsco River, drowning as many as fifty unsuspecting townspeople and factory workers. *Author's collection.*

sound. Villagers described a "wall of water" sweeping down the Patapsco. It was unlike anything they had ever seen. The normally quiet river continued to rise at the rate of one foot every two minutes. Soon, the river rose sixteen feet higher than ever before. The river that could normally be waded across with ease during a dry summer spell was now forty-five feet deep. It was described how spray and waves shot twenty feet into the air by the rushing flood. Trees and railroad ties bobbed like corks in the rushing water but struck with the force of battering rams.

The waves struck the mills along the shoreline and carried them away like matchsticks. Workers who had been too slow to get out disappeared in the current. Some of the mills were quite substantial, reaching several stories high and with stone walls reported to be as much as twenty feet thick, but they could not withstand the surge of the flood.

A group of thirteen millworkers' houses near the Frederick Turnpike bridge was soon the scene of a terrible drama. Trapped by the flood, the families living there climbed to the rooftops. Their older children had been off at school; now these children watched helplessly from higher ground with the other villagers as one by one the houses crumbled in the flood. As the houses gave way, the survivors managed to cling to the roof of the next intact house. Finally, just one house stood with as many as thirty-six people—mostly women and very young children—shouting for help from the roof. But they were beyond rescue, separated from the shore by too great a distance. And then the last house washed away. Bodies would turn up downstream for days.

"Every tree and street, the conservatory, the fences and out-buildings are swept away," wrote John F. Kennedy, supervisor at Gray's Cotton Mill, in describing the aftermath of the flood.

> *A great part of the dwelling house is in ruins, a deposit of three or four feet of white sand spread over the grass plots; quantities of stone brought down the river from the mills destroyed above, strew over this deposit, porches carried away, my library entirely taken off, leaving no vestige of books, prints, busts or other articles with which it was furnished. Mr. Bowen's house is lifted from its foundation and borne bodily away upon the flood. The devastation has so completely altered the aspect of the place that I should not know it.*

Other, smaller villages along the Patapsco were caught by surprise, with more houses and mills destroyed. In the years that followed, many such homes and businesses were never rebuilt.

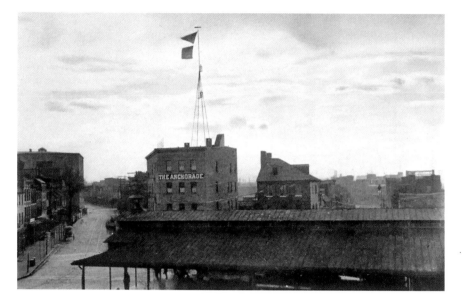

In the days before radio communication, flags were used to warn of dangerous weather approaching. This is the Maryland Weather Service station flying a storm warning atop the Anchorage building on Broadway in downtown Baltimore. The photograph appeared in the 1899 edition of the Maryland Weather Service report. *Courtesy Historical Society of Cecil County.*

A small steam tugboat that plied the upper reaches of the river found itself nearly shipwrecked by the normally placid Patapsco but managed to ride out the swells. The flood swept on toward Baltimore, where it wrecked bridges and filled the streets and then the harbor with debris such as trees, stones and lumber.

In her 1972 book *Ellicott City: Maryland's 18th Century Mill Town*, Celia M. Holland estimates the damage at more than $1 million by the time the floodwaters had ebbed. Accounts vary as to the number of lives lost, but most sources state that between thirty-six and fifty people died in the flood, making it one of the deadliest weather events in Maryland history.

Even now, it's hard to say why the flood took place under such odd circumstances, considering that no storm of any consequence struck Ellicott City or Baltimore. The only flood of similar proportions took place in 1972 as a result of Tropical Storm Agnes. That flood was understandable, considering that the entire Chesapeake region was affected by heavy rainfall. But in nearly 150 years, there hasn't been a "dry" flood similar to the one that struck in 1868.

# TEMPTING FATE

## THE GREAT GALE OF 1878 AND THE SINKING OF *EXPRESS*

*Home is the sailor, home from the sea:*
*Her far-borne canvas furled*
*The ship pours shining on the quay*
*The plunder of the world.*
—*A.E. Houseman*

Shipwreck. It's a word fraught with emotion, evoking images of heroic efforts and mournful tragedy. And yet the very idea of a shipwreck seems somehow romantic from today's perspective, more the stuff of stories and legends than a real danger of modern travel.

In the seventeenth, eighteenth and deep into the nineteenth centuries, the threat of shipwreck was a very real danger for travelers. And in those times, far more travelers from all walks of life were packed into vessels than could ever crowd onto a train. When a ship went down, the loss of life was often extraordinary.

Until about 1850, ships were relatively fragile wooden vessels that relied on wind power. Storms struck with little or no warning, leaving these ships at the mercy of waves and gales. Coastal navigation in particular was tricky at the best of times—on a stormy night, shoals reached out to snare helpless ships, or ships could be driven onto rocks or shallow water, where waves would beat them to pieces. Even the most experienced captain or pilot could become disoriented at night or in a storm. (Some unsavory characters known as mooncussers or land pirates deliberately caused shipwrecks by luring or misguiding vessels with lights on shore and then moving in to plunder the

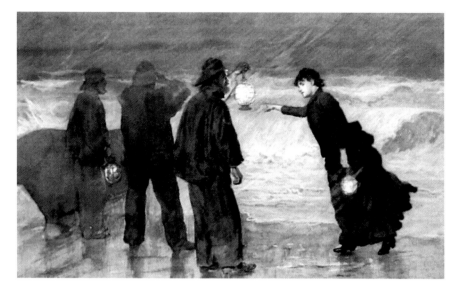

This magazine illustration by artist Charles Stanely Reinhart is entitled "Oh, don't wait! Don't lose any time! They may be drowning!" When a ship was wrecked in shallow water during a storm, those on shore could often hear the victims' desperate cries for help. *Courtesy Library of Congress.*

wreckage and the bodies of the crew. The practice wasn't unknown on the coasts of Virginia and Delaware.) By some estimates, more than two thousand ships went down in the Chesapeake Bay alone between 1608 and 2008. The Delaware Bay was even more perilous.

The rise of steam power meant that ships employed huge paddle wheels (often mounted on the sides) to power through the waves. There must have been a tendency to believe that man was finally reaching some mastery over the elements. Yet as ships grew larger and took on greater numbers of passengers, the size of shipwreck disasters also grew.

Long before the *Titanic* struck an iceberg in 1912 and met its watery doom, the wreck of the SS *Central America* grabbed headlines and illustrated the dangers of a coastal hurricane. The ship was a 280-foot, side-wheeled steamer running from Cuba to New York City in September 1857. The ship's voyage originated in Colon, Panama, where the *Central America* had taken on more than ten tons of gold ingots, all of it bounty from the Yukon Gold Rush. The valuable cargo was destined for the financial markets of New York City.

By the time the ship stopped in Cuba, nearly six hundred crew members and passengers were on board for the final leg of the voyage to New York.

The weather was hot but relatively calm, although heavy clouds began to gather. Then, on September 9, the worst fears of any nineteenth-century traveler were realized when the *Central America* sailed into the path of a Category 2 hurricane. The ship went down off the Carolina coast with 425 souls aboard and all those tons of Yukon gold. Among those lost with the ship was the heroic Captain William Herndon, for whom a town in Virginia is now named.

The loss of the ship was a horrific disaster in terms of human life—and the loss of so much gold sent New York's financial markets into a panic. Sadly, it was not the last time that an Atlantic hurricane would cause so much tragedy or kill so many.

For travelers on the Chesapeake Bay, news of the *Central America* disaster must have caused more than a little concern. This was a region where a great deal of commerce and travel was carried out by water. Yet even during the height of hurricane season, it must have been easy enough to put the event in the back of a traveler's mind on one of those beautiful fall days when the sky is a crisp blue and the breeze smells salty and fresh. When the weather is good in the Chesapeake, it's some of the best in the world. But the Chesapeake can raise a tempest on occasion.

Newspaper illustrator Alfred Waud is best known for his Civil War sketches. Here, he has drawn a vessel going down in a storm. *Courtesy Library of Congress.*

# The 1800s

Even a summer squall could make for a harrowing experience for Chesapeake Bay travelers. In her book *Life in the South*, British naturalist and memoirist Catherine Cooper Hopley described one such storm after boarding the steamer *William Selden* for Baltimore. Hopley was a wealthy woman traveling in style, with her own stateroom and cages full of mockingbirds to keep her company. She described what happened next:

> *The weather was intensely warm, thermometer approaching 100 degrees. A few heavy lurid clouds assumed a threatening appearance; but the sun was partially unobscured. Suddenly, a crash! as if a huge rock had fallen on the roof of the boat; one loud, strong, shivering crash! I rushed out into the saloon, and beheld the female passengers staring at each other in mute amazement. The machinery still throbbed, and the boat continued on its course; and, while we were trembling with alarm and wonder, the steward entered, who informed us that the ship had been struck by lightning, but, through a merciful Providence, not seriously damaged. The electric fluid had been attracted by the funnel, which it bent; and running down had found its way along an iron chain to the rudder, which was slightly splintered, and thence conducted by the iron work, had lost itself in the sea. That was all the storm. We must have been passing under a heavily-charged cloud, which spent itself in that one sharp crack.*

Hopley related that the ship came through unscathed and that she had time to make the train in Baltimore, plus do some shopping in town.

Diarist Philip Hone describes the grueling adventure travelers faced even on the East Coast in the early 1800s:

> *Baltimore, Wednesday, March 14.—Left Philadelphia at six o'clock this morning in the "Robert Morris," and came to New Castle at half-past nine, where we were transferred to the railroad; a pleasant ride, which brought us in an hour and three-quarters to Frenchtown. The railroad is just finished, and is an excellent substitute for the bad roads which travellers had formerly to encounter in crossing the peninsula. The cars are new, very handsome, and commodious, and are drawn at present by horses. At Frenchtown we took the "Independence," and arrived here this evening. The weather during the day had been extremely cold; the decks were covered with ice, and on the passage up the Chesapeake bay the wind blew so bitterly cold that the stoutest passengers were unable to remain upon deck.*

Another traveler, Lucy Larcom, described a Chesapeake Bay trip in a journal published in 1894. Her journey south seemed to start pleasantly enough:

> *Reached Philadelphia about noon. Went immediately aboard the Ohio—a beautiful boat, and a lovely afternoon it was when we sailed down the Delaware* [River]. *The city looked so pleasant with the sun shining on it, and the green waving trees about it, while the waves looked so smooth in their white fringes, that I could have jumped overboard for joy! Never shall I forget that afternoon. At evening, took the cars to—somewhere, on the Chesapeake Bay, and thence to Baltimore on another boat. Saw hedges, for the first time, in Maryland.*
>
> *Had an unpleasant sail in an unpleasant boat. Sister and S. wretchedly seasick; so was nearly everybody, but I redeemed my fame, dancing attendance from baby to the sick ones continually. The wind blew, the boat rocked, and the tide was against us. One poor little Irish woman, who was going with her baby to meet her husband, was terribly frightened. I tried to comfort her, but she said "she would pull every curl out of her old man's head, for sending for her and the baby."*

Unfortunately for Larcom, the unpleasantness did not end when the steamer reached its destination: "Came into Baltimore between ten and eleven. S. had her pocket picked on the way! Stopped at the National Hotel for the night, and left B. again in the morning, in the cars. Glad enough, too, for I hate cities, and B. worst of all."

Delmarva has been lashed by some vicious storms in the previous four hundred years. But the deadliest of all Delmarva's storms was, by far, the Great Gale of 1878. By the time the storm's fury had abated, crops across the peninsula would be ruined, homes and barns destroyed, telegraph lines knocked out and multiple ships foundered. While many lives were lost on the Chesapeake and the Delaware that autumn day, the worst loss of life would take place during the sinking of the steamship *Express*, when sixteen passengers and crew went to their watery graves.

The storm swept up from Cuba with little warning. Weather experts say the term "gale" is something of a misnomer because the storm was actually a Category 2 hurricane by today's measure. The storm followed a path similar to that taken in 1954 by Hurricane Hazel, another furious storm that a few Delmarva old-timers may recall. At the height of the 1878 storm, sustained maximum winds reached forty-five miles per hour

The Ericsson steamer and pier at Betterton, Maryland. This Kent County town was a popular destination for day trips from Baltimore. The Ericsson line also operated steamers between Baltimore and Philadelphia. The ships were tall and narrow so that they could pass through the locks of the Chesapeake and Delaware Canal. *Courtesy Historical Society of Cecil County.*

in downtown Baltimore. Rooftops and church steeples blew away. Smith Island was completely under water for the first time in memory. And out on the Chesapeake Bay, one unlucky vessel would experience the full fury of the storm.

In the years after the Civil War, the Chesapeake Bay region was booming, thanks in large part to the bounty of the bay itself. Transportation was relatively fast and easy because of the steamers that plied the bay waters. And oysters were so much in demand that places like Crisfield had become boomtowns.

The 1878 diary of Captain Thomas Rose Lake, the young master of a coastal trading sloop called *Golden Light*, provides a snapshot of the era. Weather was everything to Lake because the success of his sailing vessel depended on the right wind and tide. Here is an entry from that April, preserved in Captain Lake's own spelling:

> *4/1 Monday: Wind W in the morning Erlye. Started from New Point 6 o clock AM. Later in the day Wind NW. it got to blowing so hard Stoped in Raphannac at 11 o clock. At too o clock PM the whind died out and we*

*Started a gan. At 9 o clock in the Evening off of Smith's Point. 8 o clock in the morning anchored at St. Gorges.*

The St. George's mentioned here is a tiny island in the vicinity of the Potomac and St. Mary's River.

Lake was not an oysterman, but like many other captains of the time, he relied on the oyster trade to help him make a living. The weather was not always ideal, but the perishable oysters had to be brought to market, apparently in New York City in his case. In the following diary entry, he describes seeing the wreckage of another trading vessel that went down in rough seas near Smith's Island Light. The waves became so intense that they began to wash over the *Golden Light*. It's worth noting that Captain Lake never makes mention here of turning back or heading for port. Instead, he was forced to make the costly decision to throw oysters overboard so that the vessel would ride higher in the water.

First reports of the hurricane that would be known as the Great Gale of 1878 came early in the third week of October. It struck the West Indies on Monday and reached Florida by Tuesday before steaming up the Atlantic Coast.

Captain Lake of the *Golden Light* made note of the approaching storm in his diary. It's interesting that he never uses the term "hurricane" or "cyclone" to describe the devastating storm—today it would be defined as a hurricane—but describes it simply as a "gale."

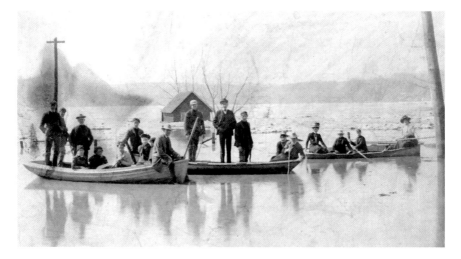

A flood seemed to be an occasion to dress up in Port Deposit, located on the Susquehanna River near the top of Chesapeake Bay. *Courtesy Historical Society of Cecil County.*

# The 1800s

*10/22 Tuesday: Clear in the morning earley. 8 o clock AM it clouded up very fast. The Sloop* Golden Light *came in to day with the Wind ESE. Anchored 4 P.M. It was blowing a gale.*

On the Chesapeake Bay, for the crew and passengers of the steamship *Express*, the storm would be a test of wills and courage that several would not survive. But on the afternoon of Tuesday, October 22, the impending storm was just a nuisance for the passengers intent on getting to their destinations. In those days, travel by water was the fastest and easiest form of transportation, and as part of the Potomac Transportation Line, the steamer made regular trips from Baltimore to Washington, D.C., stopping at points along the way.

Captain James T. Barker had heard the forecasts for rough weather and may have been uneasy about the storm. But he was under orders to keep his schedule, and no one knew the extent of the storm that was churning up the Atlantic coast toward Delmarva.

And so, around 4:00 p.m., once the twenty-one crew members and nine passengers had boarded in Baltimore and the cargo had been loaded, he headed the *Express* out of the harbor and into Chesapeake Bay. The trip and the weather were uneventful at first. But the wind began to pick up sometime after midnight. By 2:00 a.m., it was blowing a gale. And then, all hell began to break loose. The seas reached mountainous heights as the wind screamed around the ship. Men who had sailed the Chesapeake their whole lives had never seen the waters so wild.

Poor Captain Barker had few options. As Donald G. Shomette recounts in his book *Shipwrecks on the Chesapeake*, the steamer was caught between a rock and a hard place as it made its way into the storm because there were no harbors of refuge. As waves taller than the ship pounded its decks, the hold began to fill with water. The engines flooded, and the *Express* was left helpless. Unable to keep turned into the wind with its bow riding the huge oncoming waves, it was only a matter of time before *Express* turned sideways and rolled. The desperate crew and passengers prepared for the worst by strapping on life preservers or stripping down to give themselves a better chance of swimming. According to Shomette, Ship's Purser I.F. Stone would later recall that the thirty souls on board faced death rather calmly: "These preparations were silently made for the fight for life which all saw was inevitable. An audibly uttered prayer here and there, a moan of suppressed emotion from one or another of the passengers in the saloon were all the outward evidences given of the intense feeling which possessed the breasts of all on board."

Then, around 5:00 a.m., two huge waves struck the ship in rapid succession, and it was all over for *Express*. Passengers and crew were thrown into the raging water. Some clung to makeshift rafts they managed to lash together, some grasped at boards from the wreckage and one poor woman was last seen floating away on a mattress. Two women were helped into a lifeboat by the crew, who watched in horror as a wave swamped the boat and took the two down with it. Howling wind and rain were compounded by the fact that the survivors struggled in almost total darkness. It was a terrifying struggle for survival.

At first light, some survivors found themselves drifting alone, surrounded by the wreckage. The storm began to abate later in the morning. One man, Quartermaster James Douglas, thought salvation had arrived in the form of a local schooner that braved the still-huge waves. Though they had seen him, the crew members ignored Douglas and instead picked up barrels of oil and other cargo that could be resold. They apparently wanted no witnesses to their illegal salvage operation. Douglas drifted for twenty miles before another ship plucked him, suffering badly from hypothermia, from the water.

More than half of those who had left Baltimore the previous afternoon perished in the sinking of *Express*. Fifteen crew and passengers survived, including Captain Parker. Sixteen people did not, and the bodies—such as that of a young woman who had boarded as a passenger—continued washing ashore days later.

The tale of the tragic sinking of *Express* seemed to enter its last chapter in early December, when the *Crisfield Leader* published the following news item under the headline A SAD HOME-COMING:

> *A very singular affair occurred last week. Captain I.T. Sterling, of the schooner* Clara Howeth, *picked up the body of Mrs. Tarelton, one of the victims of the late steamer* Express *disaster. The body was drifting from the shoals, near Kedges' straits, into the bay. Captain Sterling carried the remains to Smith's creek, in the Potomac river, for interment, and by chance landed at the house where Mrs. Tarelton was born, married and lived, giving her body in charge of the distressed husband. One of the children lost with Mrs. Tarelton drifted across the bay, and into the Potomac river, where it too was recovered by the father. Curious coincidence, indeed.*

The storm caused its share of damage elsewhere, even on land. According to the *Cecil Democrat* of October 26, 1878:

# The 1800s

*The people in this section were awakened at an early hour on Wednesday morning by the whistling of the angry wind and the falling of the merciless rain.*

*The storm was terrific. The wind shrieked and howled along at mad pace, and the rain came down in blinding sheets. Corn shocks were torn and hurled along before the might wind; fences old and new were torn up or laid low; trees were bent and twisted off.*

*It was undoubtedly, for general destruction, the worst storm we have had for a number of years, and it would be difficult to estimate the amount of damage done. Many thousands of dollars will be required to repair or rebuild the buildings injured or destroyed in the county, and to make up for other losses.*

In Elkton, attorney George Ricketts anxiously awaited word about the ship *Northwood*—bound for Baltimore from a trip to Panama—laden with fruit. The ship was owned by a relative in Baltimore, and his son, Thomas, was a passenger who had undertaken the voyage as a youthful adventure. He may have gotten more than he bargained for. The ship was overdue in the aftermath of the storm.

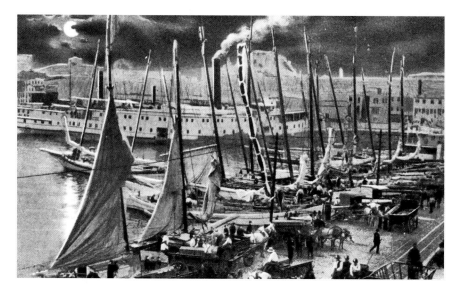

This postcard from the early 1900s portrays a scene on Baltimore's busy wharves. *Courtesy Historical Society of Cecil County.*

Around the bay, disaster abounded. The rivers rose and flooded the marshes and low places. In Baltimore, the gale was just as severe. Part of the cyclone was a tremendous storm surge that flooded waterfronts.

The towing steamer *Allison* left Locust Point in Baltimore at 5:00 p.m. that Tuesday hauling nineteen barges, eleven loaded and the others empty. As the full fury of the storm struck, the *Allison* was forced to take refuge in North Point creek. The steamer set two anchors, but they broke free in the gale. Some of the barges came free, but the rest had to be cut loose to save the steamer and its crew. They fired up the steamer's engines and ran for safety.

On land, countless barns were demolished, which speaks to the amazing force of the wind. There was a huge loss of livestock. An incident at Rising Sun near the top of the bay was typical. There, a barn was blown down and killed two horses inside.

The storm reached its height in Philadelphia between 7:00 and 8:00 a.m. with steady winds measured at seventy-two miles per hour. Churches seemed especially hard hit there, with many losing their steeples.

The U.S. Department of Agriculture Weather Bureau's *Bulletin on West Indian Hurricanes* noted:

> *It was particularly severe on Chesapeake Bay, especially between the mouth of the Patuxent River and Barren Island, where a steamer was sunk with loss of life, and several vessels were driven ashore. On Delaware Bay the storm was said to have been the most severe ever experienced, vessels of all kinds being driven ashore with loss of life. The wind blew 72 miles an hour in Philadelphia, Pa., injuring or totally destroying 700 substantial buildings; 8 vessels were sunk, and 22 badly damaged; the losses were estimated at one to three millions of dollars.*

In the wake of the Great Gale of 1878, the people of the region picked up the pieces, rebuilt what was destroyed and mourned those lost in the storm. Fortunately, it would be nearly fifty years before a hurricane of such magnitude struck the region again.

# KEEPERS OF THE LIGHT
# AND SENTINELS
# IN THE STORM

*Bitter is the wind this night*
*Which tosses up the ocean's hair so white.*
—*ninth-century Irish poem*

For Chesapeake Bay mariners, lighthouse keepers and their lighthouses became heroes in the face of storms. Rough weather can be challenging on land, but it's nothing compared to being on the water when a big Chesapeake gale or blizzard is blowing. And while the Chesapeake lacks the rocks and reefs of other waterways, it has its own dangerous shoals that have claimed ships and lives.

That's where the Chesapeake Bay's lighthouses played such an important role. Before the modern era of GPS, radar and instant cellphone communication, captains relied on a beacon burning on a stormy night to give a ship its bearings or warn it away from a dangerous hazard.

Even with today's technology, it's important to remember that hazards such as fog can remain deadly. One recent shipwreck brought on by fog took place on February 25, 2002, when four mariners lost their lives after a tugboat and the freighter *A. V. Kastner* collided in the Elk River on the upper Chesapeake Bay.

Storms took the life of more than one light keeper over the years, beginning with the very first lighthouse documented in America. In 1716, a lighthouse was built on an island in Boston Harbor, and George Worthylake was hired to keep the light burning for an annual salary of fifty pounds. He held the post

Lightship 116 is now docked permanently at the Inner Harbor in Baltimore. The 133-foot vessel saw duty for many years as a lightship and World War II patrol boat. It was badly damaged by a hurricane in 1962, when a single rogue wave is said to have carried away most of its deck gear, smashed the pilothouse and broken the anchor chain. *Courtesy Library of Congress.*

for just two years until he drowned, along with his wife, daughter and two assistants, while returning to the lighthouse from Boston one stormy night.

On stormy or foggy nights, land pirates or mooncussers sometimes lit their own lights to lure ships to their doom or snuffed the light on established beacons so that ships would run aground and their cargo could be stolen. This land-based piracy became such a problem that in 1774 the Virginia legislature made interfering with the operation of a lighthouse a hanging offense.

The first lighthouse arrived on Chesapeake Bay in 1791. Seventy-four lighthouses would be built over the next 120 years, most of them in the nineteenth century. Starting in 1852, these lighthouses came under the control of the United States Lighthouse Board, a federal agency.

The very nature of the Chesapeake called for lights that were shorter than their counterparts at Cape Hatteras or Cape Cod, where lights had to

be visible for many miles out to sea.

One of the great builders of Chesapeake lighthouses was John Donahoo of Havre de Grace, who erected smaller lighthouses of about thirty-five feet up and down the bay, including Cove Point in 1828, Point Lookout, Concord Point and Turkey Point, built in 1833 for $4,355. While these early stone lighthouses aren't particularly tall, they are sturdy and impressive. Turkey Point Light, for example, sits atop a tall bluff at the convergence of the Elk River and Northeast River, making it the highest beacon on the Chesapeake, if not the tallest lighthouse.

Concord Point Light in Havre de Grace, Maryland, is one of the few substantial stone lighthouses on Chesapeake Bay. Its first light keeper was John O'Neill, a local hero of the War of 1812 who received the post in part for his service to the town. *Author's photo.*

In his book *The Lighthouses of the Chesapeake*, Robert de Gast captures some of the loneliness experienced by Chesapeake Bay light keepers. One young man stationed at the Cherrystone Light near Cape Charles found the duty so dull and depressing that he wrote in 1909, "A man had just as well die and be done with the world at once as to spend his days here." The twenty-four-year-old also jotted poems to himself in the margins of his logbook:

> *I am sitting on the light*
> *At this woeful hour of the night (3 a.m.)*
> *And the fogbell is a-ringing overhead*
> *Seems to me this fog should stop*
> *If it does in bed I'll flop*

Perhaps because of the lonely nature of the job, those who worked the lights often kept detailed logs of their duties and of the weather. In 1923,

W.H. McDorman, keeper at the Great Shoals Light at the Wicomico River entrance, noted: "Saturday 27 December Coldest day of the season—ice as far as you can see."

McDorman would have known that ice was the great enemy for Chesapeake Bay lighthouses. Storms did rage and blow, but it was this more silent onslaught of ice that proved the greatest danger. This was especially the case for the so-called screwpile lights that sprang up around the bay starting in the mid-1800s. These keepers' houses with lights on top straddled the water on stilt-like legs, looking not much different from giant water bugs. The legs or supports were literally screwed into the soft bottom of the bay. It was an economical way to build a lighthouse, and the method withstood storms well enough but not the great floes of ice such as the ones that Light Keeper McDorman observed. Winter after winter, ice claimed lighthouses up and down the Chesapeake.

"If fire or high wind and water were feared by lighthouse keepers in other parts of the country, ice was the greatest enemy of the lighthouses in the Chesapeake, and dozens were destroyed or damaged during heavy winters," de Gast notes.

Winter came down cold and hard across the Chesapeake Bay in 1881. The previous summer had been one of the hottest on record, but anyone working on or around the bay that winter could only long for a bit of that heat. In February, an arctic chill settled across the mid-Atlantic and Delmarva Peninsula. The fields and marshes froze iron hard. And yet there was a kind of beauty to the cold that seemed to scrub the air clean. At night, the stars glittered like bright gems in the clear sky.

For the two men assigned to the Sharps Island Lighthouse near Tilghmann Island, it was a cold and forlorn duty. They must have watched with trepidation as the ice surrounding their graceful lighthouse thickened and spread as far as the eye could see, with an occasional streak of open water like a blue ribbon. Not a steamer, not a tugboat, not even the sail of a skipjack out oystering could be seen. They were utterly alone in a world gone icy and white.

And then the worst happened in the early morning darkness of February 10: ice started to pile up against the spindly legs of the lighthouse. The men could feel the floor beneath them shudder from the pressure. The lighthouse began to list to one side like a ship that had taken on too much water. The two men had a boat and could have tried to make it to safety, but they would not abandon their post.

Their screwpile lighthouse was lifted by the force of the ice, turned on its side and carried away. For the daylight hours and then again into the night, the keepers clung to the wreckage. When they were finally rescued,

# The 1800s

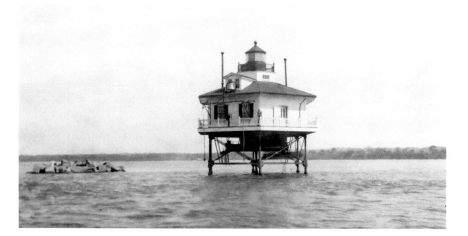

Shown in 1920, this lighthouse once stood guard at Maryland Point near the entrance to the Potomac River. It's a good example of a screwpile lighthouse, named for the stilts that had giant screws on the ends that were then driven into the soft mud of the bottom. Easy to build and once plentiful on Chesapeake Bay, they were highly susceptible to damage from shifting ice. *Courtesy National Oceanic and Atmospheric Administration/Department of Commerce.*

the keepers managed to save the all-important lens that amplified the light. In an official report to Congress, their superiors in the Lighthouse Service praised the men for not abandoning their station:

> *One instance of heroism is that of the keepers of Sharps Island light-house, in Chesapeake Bay. The structure was lifted from its foundation in February, 1881, thrown over on its side, and carried away by ice. The keeper and his assistant clung to the floating house, and, although one of their boats remained uninjured, they drifted in the bay 16½ hours without fire or food, always in imminent danger, as the heavy floating ice often piled up against and threatened to swamp the house. It grounded, however, full of water, on an island shortly after midnight, at high tide. Satisfied that it would not float off again, soon the two keepers got ashore, and when the tide had fallen they returned, saved and took to the shore the lens, its pedestal, the oil, the library (much damaged by water), and even the empty oil cans, and then reported the facts through their inspector to the Board...The two keepers who had spent those terrible hours afloat in Sharps Island light-house, and then saved its apparatus, were highly complimented by a letter direct from the Board itself...*
>
> *While it is not part of the light-keeper's duty as such to look after wrecks, or to succor the distressed, many acts of heroism have been performed by keepers of lighthouses. In those instances where, in doing so, they have*

*endangered their own lives, they have received from the Secretary of the Treasury gold or silver medals in proportion to the danger incurred, not as compensation, but rather as marks of appreciation for their services.*

That light was replaced in 1882 by a fifty-four-foot iron tower built upon a concrete base or caisson. It's interesting that the lighthouse once stood on a seven-hundred-acre island, which has since eroded and disappeared. Now the lighthouse is all that remains.

This wasn't the only harrowing escape. The severe winters of 1893 and 1894 were particularly hazardous. In January 1893, ice knocked down the screwpile lighthouse near Smith Island, but the keepers were able to flee across the ice to safety on land. That same winter, ice severely damaged the Smith Point Light, and the keepers fled for their lives. It seems incredible, but they were dismissed for abandoning their station. The light did not last much longer before it was utterly destroyed by ice on February 14, 1895.

The Wolf Trap Light was destroyed by moving ice on January 22, 1893. In 1894, ice damaged Seven Foot Knoll Light at the entrance to the Patapsco River. Ice so battered the Thomas Point Shoal Light that the lens overturned and had to be repaired. It's no wonder that in 1894, the Lighthouse Board stopped building screwpile lights in favor of the concrete caisson lights. Basically, these were built by towing an iron cylinder to the location, sinking it and then filling it with concrete. The living quarters and lighthouse were erected on these sturdy caissons.

There were other close calls. On August 28, 1893, a severe storm swept away the bridge that connected the Craighill Channel Light in the Patapsco River to the mainland, making for a harrowing time for the keeper.

As if the elements weren't enough of a challenge, the Civil War brought fresh dangers. Confederate raiders destroyed the Cape Henry Light and New Point Comfort Light in an effort to disrupt shipping and navy operations.

The storms of a different war gave rise to one of the most famous light keepers of the upper Chesapeake Bay. John O'Neill's stubborn defense of Havre de Grace during the War of 1812 is one of the Chesapeake Bay's great legends. With the British marauding on the bay in the spring of 1813, there had been a general alarm on May 2 and the local militia turned out, but the citizens' martial fervor quickly waned when the British did not appear.

But the British were only biding their time. The attack early on May 3 caught the townspeople by surprise. According to an account published in the *Baltimore Sun* in 1959 and written by Catherine O'Neill Gunther—great-granddaughter of the man who became the hero of the battle—the British

# The 1800s

Point Lookout once stood guard where the Potomac River meets the Chesapeake Bay in St. Mary's County. The shoal-filled waters have been the scene of many shipwrecks on stormy nights. *Author's photo.*

launched their attack with a fifteen-minute bombardment by nineteen barges. Rockets exploded and shells burst overhead. That terrifying show of firepower was enough to discourage any serious resistance from the local militia.

John O'Neill, however, was not scared off so easily. He operated a nail forge in town and was a militia lieutenant. O'Neill, born in Ireland in 1769, may have possessed a genetic hatred of the British. How else to explain his madcap defense of the town?

After the other defenders fled, O'Neill single-handedly manned the artillery battery near where the lighthouse now stands. According to his great-granddaughter, it was called the Potato Battery because of the size of the iron shot fired by the two six-pound and one nine-pound guns.

As rockets burst around him and grapeshot clawed the air, O'Neill kept on firing at the British until he was injured when his cannon recoiled before he could get out of the way. Bruised and battered but undaunted, O'Neill limped back to town and tried to rally a few of the militia. He used his musket as a crutch, stopping now and then to take a shot at the British.

O'Neill was captured but released when the British sailed away. He became the town's most celebrated citizen. When Concord Point Light was built in 1827, the local hero of the War of 1812 was made the light keeper for life. The job also came with a comfortable stone house for the keeper, which has today been restored and is now open as a museum.

O'Neill died in 1837 and freed his three slaves in his will. The job of light keeper passed to his son, John Jr., who held the post until his own death in 1863. This sinecure then passed to John Jr.'s daughter, Esther, until 1878 and then to her brother, Henry O'Neill. When Henry died in 1919, the job fell to his son, Harry. O'Neills might still be carrying up the whale oil and lighting the lamp, but the federal government installed an automatic electric light in the late 1920s and eliminated the light keeper's post. The lighthouse was decommissioned in 1975 but is maintained today by the Friends of Concord Point Lighthouse.

Another of the better-known light keepers on the upper Chesapeake was Fannie Salter, keeper of the Turkey Point Light from 1925 to 1947. It was unusual for a woman to be assigned such a post, particularly in such an isolated locale. She was not the first female keeper at Turkey Point. In 1844, Elizabeth Lusby had been given that post after the death of her husband, Robert, the first light keeper there. She served until 1861. In 1895, Mrs. Clara Brumfield assumed the post and served until 1919. Like Mrs. Lusby, Salter was appointed to fill the post after her husband's death. For more than two decades, Fannie Salter kept the light burning to guide ships using

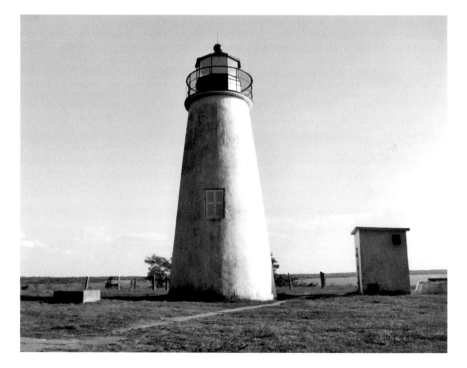

Turkey Point Light Station still stands today on its bluff high above the confluence of the Elk and Northeast Rivers. *Courtesy Historical Society of Cecil County.*

Lighthouses sometimes turned up in unusual places on the Chesapeake Bay. This mural at the Chesapeake and Delaware Canal Museum in Chesapeake City, Maryland, depicts the lock that vessels once passed through. The locks were removed in the 1920s, and the waterway became a sea-level canal. At right is the tiny lighthouse that once guided vessels through the canal. A full-size replica of the light still stands today on the museum grounds. *Author's photo.*

the busy channel that linked Baltimore and Philadelphia via the Chesapeake and Delaware Canal. Upon her retirement in 1948 she noted, "Oh, it was an easy-like chore, but my feet got tired, and climbing the tower has given me fallen arches." Though decommissioned in 2000, the lighthouse was relighted in November 2002 as an unofficial guide to navigation.

One of the more unusual lighthouses was the Bethel Bridge Lighthouse, which guided vessels on the Chesapeake and Delaware Canal. This thirty-foot wooden lighthouse had a hexagonal shape, and a replica of it was built in 1996 and now stands once more along the canal in Chesapeake City, Maryland. Several such lighthouses once lined the canal, but they were not so much "beacons in the night" as traffic signals, alerting vessels when the locks were ready to enter.

By 1939, the United States Coast Guard had taken over administration of all lighthouses on the Chesapeake and beyond. In some ways, it was the beginning of the end of the romantic era of lighthouses. The lone light keeper and his family were no longer needed to keep the oil light burning on stormy nights. More and more, that duty fell to young Coast Guard crews. And increasingly, most lights on the Chesapeake were electrified and automated, until the era of light keepers and manned lighthouses finally came to an end in the late twentieth century.

# SNOWBOUND

## THE GREAT BLIZZARDS OF 1888 AND 1899

*In our eaves and around our dormers*
*The wind cries and moans with increased*
*Force, and the night comes on.*
*—Hayden Carruth, "Snowstorm"*

In 1888, Grover Cleveland was president. The National Geographic Society was founded in Washington, D.C. In London, a killer known as Jack the Ripper stalked the streets. And across America, it would become a year forever synonymous with blizzards. The first of these infamous storms struck the Great Plains in January 1888. The storm became known as the Children's Blizzard, so named because most of its 235 victims were children caught out in the open as the freezing squalls struck. On the East Coast, a late-season storm would become known as the Great White Hurricane and cause as many as 400 deaths. The late 1800s were unusual on the Chesapeake Bay for bringing two fierce blizzards. The Great White Hurricane would soon be followed by the Great Eastern Blizzard of 1899.

According to the National Weather Service, the worst of Maryland's winter storms are actually nor'easters marked by heavy snow and high winds. "First, an arctic air mass should be in place," explained Barbara McNaught Watson in an article for NOAA's website about Maryland winters.

*High pressure builds over New England. Cold, arctic air flows south from the high. The dense cold air is unable to move west over the Appalachian Mountains and so it funnels south down the valleys and along the Coastal*

# The 1800s

*Plan. This is called "cold air damming." To the east of the cold air is the warm water of the Gulf Stream. The contrast of the cold air sliding south into the Carolinas and the warm air sitting over the Gulf Steam creates a breeding ground for storms. With the right meteorological conditions such as the position of the jet stream, storm development off the Carolinas may become explosive.*

The end result for Marylanders would be the high winds, blowing snow and bitter cold of a Chesapeake Bay nor'easter. Those who live along coastal areas are particularly prone to feeling the wrath of the storm.

These ideal storm conditions are just what took place in March 1888. This famous storm was especially devastating to New York City, which found itself buried under heavy snow. The Chesapeake Bay was just inside the southern edge of this storm. A great deal of freezing rain was mixed with the storm here, coating tree branches along with those new-fangled electric and telegraph wires. When the wind kicked up—reaching nearly fifty miles per hour at the height of the storm—down came those trees and wires.

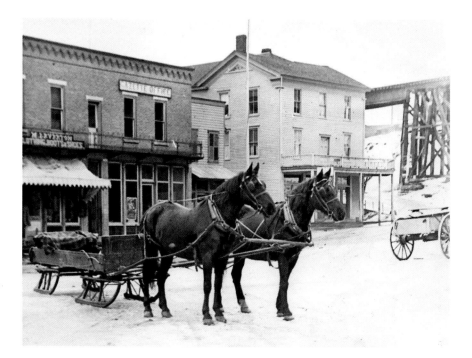

When roads snowed over in the 1800s, horse-drawn sleighs were sometimes the best means of travel. This appears to be a town along the Susquehanna River, possibly Old Conowingo, which was later submerged by the construction of Conowingo Dam. *Courtesy Historical Society of Cecil County.*

Baltimore was completely blacked out except for those neighborhoods and homes that might still have gas or oil lamps.

Of particular note on the Chesapeake was the fact that the duration and intensity of the wind literally blew the water out of the bay. On the tidal Potomac, dust was seen blowing in the riverbed. At Baltimore harbor, ships were left sitting on the muddy bottom. Navigation came to a halt in much of the bay due to low water levels.

Communication being poor and weather forecasting still in its infancy meant that many vessels were caught on the bay when the storm struck. The lashing ice and snow drove ships aground. Hardest hit of all was the Chesapeake Bay oyster fleet. An estimated forty men died when their oyster boats capsized and sank around the bay.

The straightforward prose of the Maryland Weather Service report sums up what was a devastating storm:

*On March 11–12, 1888, during the prevalence of the general blizzard over the Middle and North Atlantic states, severe weather conditions were experienced generally throughout Maryland. At Baltimore the storm ended*

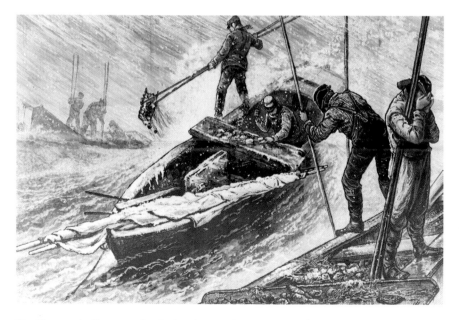

On Chesapeake Bay, oystering in the nineteenth century sometimes took place in stormy conditions. These hand tongers are shown working even as a gale blows and their small boats ice over. *Courtesy Library of Congress.*

*during the night of the 11^th–12^th and was followed by cold weather, the wind coming from the northwest throughout the 12^th causing the lowest tide for many years, the bottom of the harbor being exposed in many places. The tide in the harbor* [at Baltimore] *did not regain its normal height until the 16^th. Reports from the surrounding country and from Chesapeake bay showed the storm to have been very severe, and many vessels arriving on the 14^th and 15^th reported having experienced remarkably rough weather.*

While the Great White Hurricane was vicious on Chesapeake Bay, one of the truly epic winter storms ever to hit the region came on February 10–11, 1899.

In the final year of the nineteenth century, William McKinley was president. He would be the last Civil War veteran to serve in the White House. The Spanish-American War had just ended, and at least one Marylander, John A. Kay, from the quiet Cecil County town of Rising Sun, was among the 250 men who died in the explosion aboard the USS *Maine*. Teddy Roosevelt and his Rough Riders had exacted revenge. It was the year the paper clip was invented and the Bronx Zoo opened. The first automobile fatality in the world occurred. The historian Bruce Catton was born, as were dancer Fred

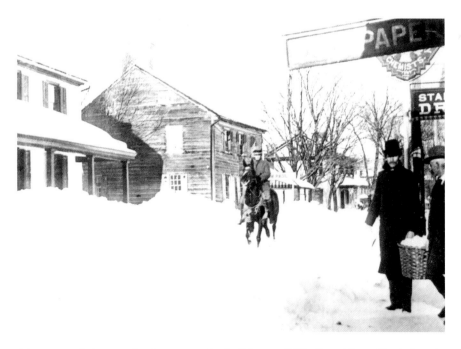

A horse was the best mode of transportation in February 1899 after a blizzard buried much of Maryland in up to three feet of snow. *Courtesy Historical Society of Cecil County.*

Astaire and writer Vladimir Nabokov. In Baltimore, a young reporter named H.L. Mencken was just getting started in the newspaper business. He would soon find himself trekking through huge snowdrifts to work on his first story.

Everywhere one looked, there was a Maryland that was racing toward the modern age and that seemed to be bursting at the seams to enter the twentieth century. And yet, there was much about the Chesapeake Bay region we take for granted today that was still far in the future in 1899. It was true that Marylanders had one foot in the new century, but the other foot was very much in the nineteenth.

First and foremost was the fact that the age of the automobile had not yet arrived. Traveling to another town meant hitching up the horse-and-buggy or walking. At the same time, the railroad system was highly developed. Tracks reached to almost every town of consequence. Since the 1860s, for instance, the residents of the town of North East on the upper Chesapeake Bay could catch one of several trains that ran each day to Baltimore and Philadelphia. Train service was fast and reliable, not to mention affordable, and these trains gave Marylanders a great deal of mobility and prosperity.

The other important mode of transportation, especially for those who lived around the Chesapeake Bay, remained the steamship. It was still the Age of Steam, and travelers depended on services such as the Ericsson Steamship Line. Traveling around the bay by steamship was fast and efficient, considering that the Chesapeake Bay Bridge wouldn't be built for another fifty years.

Communication was almost as instantaneous as it is today. Telegraph lines stretched to the smallest villages. Alexander Graham Bell had received a patent for the telephone in 1876, and telephones were already beginning to arrive in middle-class homes.

As they had since colonial times, the people of Chesapeake Bay continued to make their living off the water. And in 1899, that meant oystering. The supply of oysters still seemed endless, and thousands of men worked to pluck as many as possible from the bay's great oyster reefs. The harvested oysters were canned or shipped fresh by train to Philadelphia and New York. These oystermen, so desperate to make as much as they could during the short oystering season, would suffer terribly during the storm. Several others would be lost in the blizzard.

While the month had started with seasonable temperatures of twenty-seven degrees on February 5–7, the weather had turned viciously cold when a great arctic air mass rolled down and hovered over the mid-Atlantic and Delmarva Peninsula. In the days before the storm, the temperatures almost seem unreal today. More than a century later, records set during that cold wave still stand. Charlotte Hall hit minus nineteen. Fallston in Harford

County was minus fourteen. Out in Carroll County, the temperature fell to minus twenty-three degrees. On February 10, the thermometer dipped to minus ten in downtown Baltimore. That was the air temperature; what the wind chill must have felt like is chilling indeed. It goes without saying that the ground froze solid, as did much of the Chesapeake Bay. In temperatures that savage, keeping warm and covered up became a matter of survival for so many of the men and women forced to work outdoors or on the water.

In Ocean City, the surf froze on the beach and left the lifesaving station stranded and its crew under "great personal privation." The Susquehanna River ice was fourteen inches thick at Havre de Grace. The Potomac froze over. Tangier and Pocomoke Sounds were closed to vessels. The Chesapeake Bay froze from below the Potomac to its northernmost reaches.

The cold would have been bad enough. But then came the snow. The storm began on a Saturday night. Without real forecasts or warnings, the heavy snow caught many unawares, whether they were on farms with livestock to care for or working that bitter night on the water, trying to bring in the oyster harvest.

What makes the storm exceptional was not only the extreme cold but also the fact that the storm lasted over several days. The storm worsened during the night, continued through Sunday and reached its height during the early morning hours of February 13. Winds reached thirty miles per hour, and the temperature was seven degrees in Baltimore.

When the snow finally stopped, those who ventured out were greeted by an incredible sight. Thirty-two inches of snow had fallen in Baltimore over several days. The high winds piled the snow into enormous drifts. The young, determined reporter H.L. Mencken trudged through them to write one of his first stories, about a buggy theft. Interestingly enough, it doesn't seem he was given any assignment to write about a far more newsworthy event, which was the storm itself.

Over on the Eastern Shore, in Easton, the blizzard left behind 21.4 inches of snow after falling for sixty hours straight. The consequences of the storm were dire and devastating. The *Easton Gazette* of February 18 reported on events: "They Had No Food, No Fire and No Money. Distressing Condition of the Poor, Caused by the Cold and Snow Storm, Most Probably Without a Parallel for Intense Severity. Such is the condition of a number of suffering families right here in our midst. If you have an ounce of charitable blood in your veins attend a meeting a 2 o'clock to-day at John Mason's Furniture Store, to help devise some efficient plan for relief."

The *Baltimore Sun* reported, "Business was practically at a standstill. Many stores were closed and few persons were on the street. Numbers of people

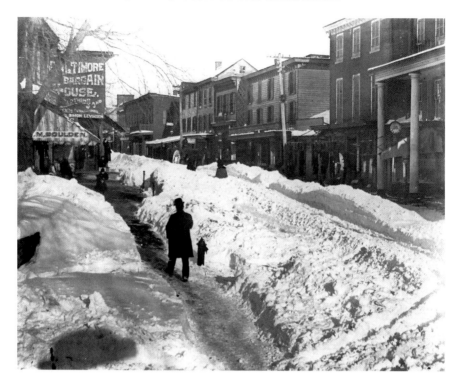

In the waterfront town of Elkton, a pedestrian makes his way along the path shoveled out in the wake of the Blizzard of 1899. Main Street remains hopelessly clogged with snow. *Courtesy Historical Society of Cecil County.*

forced to be out were overcome by the exposure, but only one fatality was reported—that of Harry E. Vincent, 2235 East Chase street, who fell exhausted in the snow near his home and died of exposure."

Counting the snow that had fallen in the days leading up to the weekend storm, the snow was now at least three feet deep in most places around the Chesapeake Bay. The wind blew it into enormous drifts. The *Sun* described how in Frederick County, the snow had drifted up to twenty feet deep and reached to the second story of many homes. A passenger train became stuck in a snow drift between Laurel, Maryland, and Washington, with a congressman among the stranded. "In all parts of Maryland there was for two or three days almost complete stoppage of travel by rail and steamboats, and for a much longer time by public roads," the *Sun* reported.

The storm was particularly hard on the Chesapeake Bay oyster fleet, whose oystermen found themselves stranded in the ice. Short on food and fuel, they abandoned their entrapped skipjacks and crossed the ice toward land. It was

Three massive steam locomotives were used to plow snow off the tracks after the Blizzard of 1899. Drifts measured up to several feet deep on the tracks, which at that time were the main travel route up and down the East Coast. *Courtesy Historical Society of Cecil County.*

a matter of survival. But even on land, conditions were dire. The crew of an oyster dredger caught at Drum Point made it to shore in Calvert County and then headed north to Baltimore. Someone later made a discovery of the bodies of these five men, who had all died of exposure in the cold and snow. Other crews struggled through the drifts and reached Baltimore, frostbitten and starving after marching for eighty miles through desolate, snowbound country.

The storm also resulted in some more unusual incidents. Funerals had to be suspended for weeks in some cases. The telephone line to the marriage bureau in Elkton must have been working, because the *Sun* reported that marriage licenses would be guaranteed over the phone so that weddings could go on in front parlors and rural churches. What a relief that must have been to snowbound couples.

The cleanup went on for weeks. In New York City, hit hard by the same massive storm, eight thousand men were hired to dig snow at $2 per day. They needed two weeks to shovel 400,000 wagons full of snow. The national cost of the storm was estimated at $20 million (more than $500 million in today's dollars).

The numbers, facts and figures from the 1899 storm can pile up like a snowdrift. It's no wonder that even today it remains one of the worst blizzards on the Chesapeake Bay.

# HOW CURIOUS

## HAIL, LIGHTNING AND THE HEYDAY OF THE MARYLAND WEATHER SERVICE

*Some are weather-wise, some are otherwise.*
—*Benjamin Franklin,* Poor Richard's Almanac

An interest in weather science exploded in the late 1800s with the availability of affordable instruments. New discoveries were helping weather experts in the new fields of meteorology and climatology gain a better understanding of how weather worked. Part of the discovery process involved good records of weather events. Now that the middle class could afford instruments to measure the weather, a legion of amateur weather watchers sprang up in cities, towns and farms. The closest comparison to this sudden interest in the weather might be the rise today of sites such as Weather Underground that enable backyard weather watchers to post their weather stations online and share data, as well as live cams.

Weather buffs would have to wait another century for the Internet, but in the 1800s, they did not lack for enthusiasm and thoroughness. In writing about the Chesapeake region's storms—and some of its unusual weather in general—one of the best resources remains the records of the Maryland Weather Service. Founded in 1891 as a joint organization among Johns Hopkins University, the Maryland Agricultural College and the United States Weather Bureau, the mission was a thorough and scientific analysis of the state's climate. The Maryland Weather Service published several large volumes, beginning in 1894 with *The Climatology and Special Features of Maryland: First Biennial Report of the Maryland State Weather Service 1892–1893.*

The Maryland Weather Service office at Johns Hopkins University in Baltimore, circa 1899. Note the signal flags and large weather vane on the roof. *U.S. Weather Bureau photograph.*

This was followed with three substantial volumes published from 1899 through 1910. To simply call these "weather records" doesn't do them justice. Beautifully bound, printed on acid-free paper that endures today and illustrated with black-and-white photographs, these are well-written accounts of Maryland's climate, soils, meteorology and plant life. The details are exhaustive.

The prominent magazine *American Naturalist* noted in 1900:

> *If the plans of the Maryland Weather Service and Geological Survey are carried out to a finish, that state will in a few years have the most complete record of natural resources ever made for a single area. The Weather Service proposes to investigate land forms, weather, water, climate, soil, forestry, crops, fauna, and flora; the Geological Survey is studying earth physics, rocks, and minerals. Both organizations are under the efficient management of Professor William Bullock Clark, supported by state funds and by a corps of scientific assistants picked from Johns Hopkins University.*

The director and impetus behind the Maryland Weather Service was Dr. William Bullock Clark, professor of geology in the Johns Hopkins University

Forecasting equipment at the Maryland Weather Service in Baltimore, about 1899. *U.S. Weather Bureau photograph*.

and state geologist of Maryland. The service was founded with a budget of $2,000. He was the director for twenty-five years. It would be hard to find anyone past or present who had such a busy and accomplished career in public service and scientific research. He died in 1917 of a heart attack at his summer home on the island of North Haven on Maine's Penobscot Bay at the relatively young age of fifty-seven. One can only wonder how much more he might have accomplished.

Thanks to the efforts of the Maryland Weather Service, there are some incredibly detailed weather records from those twenty-five years. While the weather over a quarter of a century is only a brief snapshot in terms of time, it is representative of seasonal storms, not to mention some of the stranger phenomena.

Here is a Baltimore hailstorm of April 27, 1890, as described in the *Journal of the Office of the Weather Bureau*:

> *There was a sound like a roll of musketry, and the storm burst suddenly upon the city with an almost deafening roar as the great hail stones rained down upon the tin roofs and crashed into windows, not a building in the path of the storm escaping damage.*

*As the wind blew with "great force" and felled trees, the hail pelted man and beast alike. The hail stones were described as being large as hen's eggs, while some that littered the ground were big as a man's fist. Several measured more than 2 inches in diameter. Three weighed together 12 ounces. Several persons were knocked down by the stones, and many, including a number of children, were cut and bruised. Horses, pelted and cut until the blood streamed from them, could not be controlled, and many ran away, damaging the vehicles and injuring the occupants.*

*Rain fell in torrents with the hail (.80 inch falling between 3:45 p.m. and 4 p.m.), pouring through the shattered skylights and windows, and flooded the houses.*

*All told, damage from the sudden hailstorm was estimated by weather service officials at $60,000 to $100,000, mainly due to the cost of replacing thousands of shattered windows.*

In 1946, William L. Taylor (seated) was the day operator of the Baltimore & Ohio Railroad in Cecil County and Thomas Taney was the Western Union operator. Telegrams and trains were still important links to the outside world for rural areas of Maryland. *Courtesy Historical Society of Cecil County.*

*A hail storm in downtown Baltimore was destructive to buildings, for the most part. In the countryside, a similar storm could threaten a livelihood when entire crops were destroyed in the field. Taken from the pages of* Tilton's Journal of Horticulture and Florist Companion *in 1870 is this description of one such storm that struck the upper bay region: "We have been visited to-day with one of the greatest hail-storms that it has been our misfortune to be pelted with for many years; and the damage done by it is very great, at least with and near us, and I suppose it has visited a large extent of country in the same hurried manner, leaving destruction and blighted hopes in its wake," wrote correspondent David Z. Evans Jr., describing the storm that struck the Cecil Fruit and Truck Farm at Chesapeake City, Md., on May 10, 1870.*

*It commenced at or a little after two o'clock, P.M., lasting for about twenty minutes or half an hour; and, although of such short duration, an immense amount of hail fell, most of the stones larger than a pigeon's egg, the hail being accompanied by a most violent and dashing rain.*

*The truck [produce] of different sorts has been badly cut by this unseasonable and much-to-be-regretted hailstorm, which, like a pestilence, carried death and destruction with it, one on each arm. The tomatoes, cabbages, sweet potatoes, etc., have been cut up, as well as down; and I do not see how such a storm could pass by without inflicting a greater damage than it did; for the hailstones made holes in the ground an inch and over in depth. I would like to send you one by mail as a "specimen copy," but I am afraid it would run off before it reached you.*

Back at the Maryland Weather Service, officials also provided an overview of other weather dangers, such as lightning:

*The following facts in regard to the loss of life and property by lightning in Maryland have been obtained from Bulletin No. 26, of the U.S. Department of Agriculture, Weather Bureau, just issued: During the three years, 1896–1898, there were nine deaths in Maryland by lightning as against thirty-five in Virginia, six in West Virginia and seventy-one in Pennsylvania for the same period. Of the Middle Atlantic States, which taken together average five deaths per million population per year, Maryland has the smallest ratio of deaths by lightning, being three per million people, while Virginia has seven and Delaware six.*

*During the six years, 1890 to 1897, there were 143 barns, 41 dwellings, 1 church, 2 factories, and 6 buildings of other kinds, or 193*

*in all, set on fire by lightning, in this state. During 1898 there were 22*
*buildings struck and damaged by lightning, occasioning a loss of $10,785;*
*also 5 head of cattle and 3 horses were killed in the field.*

Weather service officials offered summaries of the state's overall
meteorological tendencies:

*Maryland is seldom visited by storms of such severity as to cause much loss*
*of life or property. Those of greatest violence have their origin in the West*
*Indies and move northward along the coast, and are usually more destructive*
*in their effects over the South Atlantic states and along the New England*
*coast than on the Middle Atlantic seaboard—a fact already mentioned*
*under the heading of storm types. According to General Greely* [author
of the 1888 book American Weather], *the recorded instances of*
*tornadoes in Maryland are only about five since 1794, while the number*
*reaches thirty over portions of Georgia on the south and from fifteen to thirty*
*in the vicinity of the Lakes on the north and northwest. Local thunderstorms*
*and hailstorms are occasionally quite severe, but on the whole the state lies*
*in an area less frequently visited by severe general storms than almost any*
*other east of the Mississippi river.*

Other notes on the weather include:

*One of the most severe storms of recent years was that of September 29,*
*1896. This storm was very destructive to timber, uprooting or snapping*
*off thousands of trees throughout the state. Of the more populous centers,*
*Washington City suffered most, where the wind reached a maximum velocity*
*of sixty-six miles per hour from the southeast; several large buildings were*
*blown down, one life was lost, and a general loss of property occasioned to*
*the amount of $400,000.*

*On July 17, 1897, Baltimore was visited by a severe local storm, the*
*lightning, wind and rain doing much damage to city property.*

*On December 4, 1898, during the passage of a west Gulf storm,*
*considerable damage, amounting to about $100,000, was done in*
*Baltimore. The wind blew at the rate of sixty miles per hour for four*
*consecutive minutes, during which time over two hundred houses were partly*
*or wholly unroofed, and innumerable signs, awnings and shutters were*
*blown away or wrecked.*

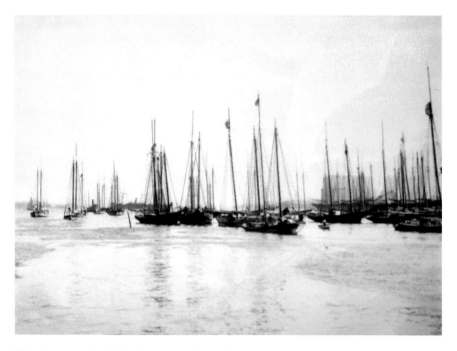

This photograph is labeled "the oyster fleet at Baltimore" and shows skipjacks anchored in the harbor. The business of oystering went on during the winter months no matter what the weather, and more than a few Chesapeake Bay oystermen were lost in storms and gales. *Courtesy National Oceanic and Atmospheric Administration/Department of Commerce.*

Eventually, the state's independent weather service was disbanded as the National Weather Service rose in prominence. But the contributions of those early weather experts endure today, in that their work remains one of the most ambitious studies of local weather ever undertaken.

# PART III

# THE 1900s AND BEYOND

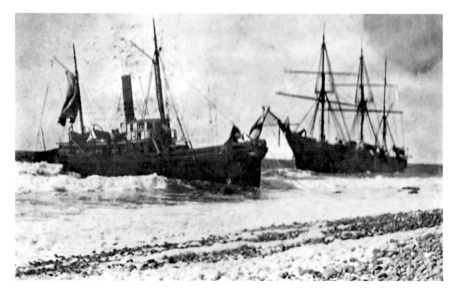

The USS *Nina* (left) is shown here with the wooden USS *Tallapoosa* in 1884. The *Nina* was a very old steam-powered tug that first entered the service in 1865. Stationed at the Washington Navy Yard and then assigned to the Lighthouse Service and later the submarine service, the 137-foot tug was a real workhorse of its day. On February 6, 1910, *Nina* left Norfolk, Virginia, bound for Boston and was last sighted that day off the Capes of the Chesapeake in the midst of a gale. One month later, the navy declared the *Nina* lost at sea, along with thirty crewmen and one officer. *Courtesy Naval Historical Foundation.*

# THE ONCE-IN-FIVE-HUNDRED-YEARS STORM

## TROPICAL STORM AGNES

*The best thing one can do when it's raining is to let it rain.*
*—Henry Wadsworth Longfellow*

If there is one storm that serves as a benchmark, a kind of end-all, be-all of Chesapeake Bay storms in modern memory, that would be Tropical Storm Agnes. It's a storm that has left its mark not only on Chesapeake Bay but also on communities and states far beyond, and sometimes in strange ways.

For example, in high school, I worked for several summers as a camp counselor at Broad Creek Memorial Scout Reservation in Harford County, Maryland. The central area of the Scout camp is taken up by a shallow, generally muddy body of water known as Lake Straus. The lake was created in the 1940s by damming up Broad Creek, a tributary of the Susquehanna River. This lake was once much deeper and clearer but has become badly silted in over the decades by topsoil from farm fields and, later, by runoff from development.

When you hike below the lake along the banks of Broad Creek, you will see some really beautiful and pristine woods. Hikers will encounter a strange sight, however, up in the trees. To this day, the mangled remains of aluminum canoes and rowboats can be seen wrapped around tree trunks as tightly as twist ties, sometimes twenty feet in the air. It seems impossible that the water could have ever reached that height. Yet in June 1972, these craft were carried off by the raging flood caused by Tropical Storm Agnes and swept over the dam and then down among the trees as a lasting monument

to one of Maryland's worst episodes of flooding. One can forgive the Scouts for being caught off guard by the flood and not moving their rowboats and canoes to higher ground. For the most part, this storm caught everyone by surprise.

Agnes never was much of a hurricane. The storm began on June 14 over Mexico's Yucatan Peninsula—in itself somewhat unusual for an Atlantic hurricane—and churned across the Gulf of Mexico toward the United States. Marylanders might not have been paying much attention to news of this distant tropical storm. There were more newsworthy events closer to home, such as the attempted assassination of George Wallace at a Laurel, Maryland shopping center. On June 17, five men were arrested in connection with a break-in at the Watergate Hotel; the resulting scandal brought to light by the *Washington Post* would eventually implicate President Richard M. Nixon. Impeachment and resignation would follow for the president.

And yet off stage, a storm was brewing. The storm was dubbed Agnes on June 16 and, two days later, had sustained winds of seventy-five miles per

In the wake of Tropical Storm Agnes in 1972, high water from the Susquehanna River floods the town of Port Deposit. The marina docks are under water as well. *Courtesy Historical Society of Cecil County.*

hour. As the storm moved toward Florida, winds reached eighty-five miles per hour. Hurricane Agnes had arrived. The storm was only a hurricane for a few hours at most. The wind speed diminished, and the storm fizzled to become a lumbering tropical depression as it shifted into Georgia. Far to the north, there didn't seem much to be worried about.

But a few days later, a tremendous change had taken place. According to weather experts, a series of unusual events suddenly positioned Agnes, which had been down and out, as a fresh powerhouse. A second low-pressure system appeared from the west, pushing what had been Agnes toward the sea. The two big low-pressure systems then began to travel side by side up the coast. Agnes pulled fresh energy—and tremendous amounts of water— from the sea. By June 21, Agnes was revived as a tropical storm.

To make matters worse, the compounded systems took an unusual path inland rather than following the coastline in the more common storm track. And then the two storm systems merged and swung toward Chesapeake Bay, inland Maryland, Pennsylvania and upstate New York. It didn't help that the spring had been wet already so that Agnes struck just when the ground was saturated, with streams and rivers already running high. And then the massive storm stalled. Stuck over the region, Tropical Storm Agnes began to lose the moisture it had accumulated in its journey from the sea.

It was a situation that no expert could have predicted. It's no wonder that nobody bothered to secure the canoes at the Scout camp because they were dozens of feet from the lake's edge—a lake that hadn't been known to flood much at all. The heavier rowboats were likewise high and dry or tied securely to the docks. When it came to Agnes, it wouldn't be enough.

Imagine the hardest summer downpour going on…and on. So much rain, over such a large region, had never been seen before and very likely won't be seen again for years to come—perhaps not even for centuries. This was not an isolated heavy downpour but a regional event.

The rainfall amounts over the next twenty-four hours were staggering. According to National Weather Service records, 14.68 inches fell at Westminster in Carroll County and 13.85 at Woodstock along the Patapsco River in Howard County. To give these rainfalls some perspective, keep in mind that the previous twenty-four-hour record had been set at 7.31 inches in Elkton on August 11–12, 1928.

Up in Pennsylvania, the rain was coming down like a fire hose. The state capital at Harrisburg saw fifteen inches of rain. Schuylkill County had a reported nineteen inches in twenty-four hours. Of particular concern were the towns along the Susquehanna River. According to the Susquehanna

River Basin Commission, the Susquehanna is one of the most flood-prone rivers in the United States. And in the wake of Agnes, flood it did.

To understand the full impact of this storm on the Chesapeake, it's important to understand the geography of the river, which has its headwaters in Cooperstown, New York. The river then winds 484 miles past several major industrial towns before reaching the Chesapeake at Havre de Grace, Maryland. The river drains a 27,500-square-mile region—each square mile of which had received untold millions of gallons of rainfall in just twenty-four hours. The Susquehanna simply could not be contained. Whole towns were inundated by the surging river. At Harrisburg, the first floor of the governor's mansion was under water. Governor Milton Shapp and the first lady, Muriel, had to be rescued by boat. (The governor would later quip that Hurricane Agnes was "Hurricane Agony" as far as he was concerned.) At Wilkes-Barre, ordinary townspeople rushed to help build sandbag dykes to help contain the flood. But the river rose so rapidly that officials ordered the volunteers to evacuate.

All that water was now racing downstream toward the Chesapeake. Of particular concern was the Conowingo Dam. Completed in 1928, the dam spanned the mighty Susquehanna just above the town of Port Deposit in Maryland. Rising 116 feet above the surface of the river, Conowingo Dam at

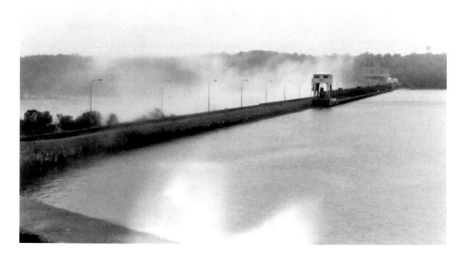

At the height of flooding brought on by Tropical Storm Agnes, the Susquehanna River came close to flowing over Conowingo Dam. If the dam had given way, the damage downriver would have been incalculable. *Courtesy Historical Society of Cecil County.*

that time was the eighth-largest hydroelectric dam in the nation, generating 474,480 kilowatts of power.

In spare but lovely prose, veteran newspaperman Clark Samuel recounted the flooding in the *Havre de Grace Record*, describing how residents "lined the banks of the river to watch with fear and awe, the swift passing parade of debris, as boats torn loose from moorings pitched crazily in the angry rolling waters, along with huge timbers, uprooted trees, sides of barns and other flotsam, the origin of which may have been miles up river into Pennsylvania and New York states where it had accumulated in the onrushing tide which swept everything before it."

Behind the dam was nearly all the water from that sprawling, flooded watershed. The dam contained what was known as Conowingo Pond, a body of water fourteen miles long and more than a mile across. For the entire length of the pond, the water was now three feet higher than normal. Conowingo Dam was holding back an incalculable amount of water. How much more could it hold back, and for how long?

Massive as it was, the forty-four-year-old dam had never withstood a flood of this magnitude. All fifty-three flood-control gates were opened so that the floodwaters could rush through, but even that was not enough. The water behind the dam began to rise higher and higher. Fearful that the dam might be crested by the flood and give way entirely, officials placed explosives so that a section could be blown open to allow more water through.

In the early hours of June 24, even with the floodgates wide open, the flood came within 5 feet of running over the top of the dam. Concerned about whether the concrete barrier would hold, the dam supervisor warned in a special bulletin that the dam's stability "cannot be controlled. When it reaches 111 feet…it will be in the hazy area…It is not known…whether a structure of the dam may give and…people downstream should be advised."

No one was quite sure what might happen next—flooding of this magnitude was totally uncharted territory. Downstream, there was real concern about the fate of the towns of Port Deposit, Perryville and Havre de Grace, all located on the river. If the dam failed, hundreds of homes could be destroyed.

Evacuation orders were issued by local officials. In Havre de Grace, the residential section of the city closest to the river was evacuated, and the county hospital in Havre de Grace evacuated for fear it might be swept away if the dam broke. Residents of Perryville received a cryptic evacuation order as officials handed out notices door to door: "Due to the insecurity of Conowingo Dam, the Town Commissioners have declared a State of Emergency for Perryville."

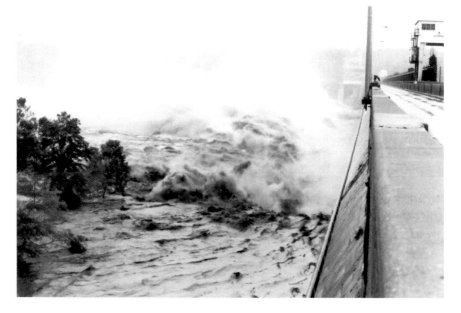

Water roars through the floodgates at Conowingo Dam in June 1972 in the aftermath of Tropical Storm Agnes. At the time, officials feared the Susquehanna might overflow the dam and so made plans to dynamite a hole to let more water through. *Courtesy Historical Society of Cecil County.*

Five miles below the dam, sirens sounded in the town of Port Deposit. The town had a long history of floods. Built between the riverbank and the high bluffs that rose above the Susquehanna, the town basically occupied a flood plain. No stranger to incursions from the river, the town had been invaded time and again by huge floes of ice from the Susquehanna in the days before the dam. But this time was different. The flood that was now creeping through the streets, alleys and houses was beyond any reckoning in living memory. Rising water was one thing, but the threat of the entire dam giving way was another.

All one thousand residents in town were ordered to evacuate. Some fled to the homes of friends or relatives, while others made do at an emergency shelter set up at Bainbridge Naval Training Center, high above the river. Firefighters and police went door to door making sure that the town was empty. The roads out of town would soon be flooded, and clinging to the cliffs above town was not an option for most. Some waited too long as the water rose, making evacuation difficult and creating a hazard for motorists. Problems and rescues multiplied throughout the region as people either tempted fate or were taken by surprise by the scope and scale of the flooding. As Thursday morning dawned, many businesses announced they would be

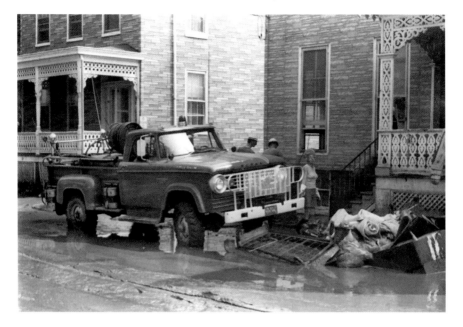

Agnes left mud-filled streets and houses behind after record flooding in June 1972. Here, residents of Port Deposit clean up after the Susquehanna River has receded. *Courtesy Historical Society of Cecil County.*

closed for the day. Aberdeen Proving Ground shut down, as did Bata Shoe Company at Belcamp, at that time one of the area's largest employers.

Newspaper reporter Bob Davis described driving down Route 7 in Cecil County and seeing what he thought was a foot or so of water across the road. "I went into the water slowly, and promptly got stalled in about one and a half feet of water," he wrote. Bystanders helped him push the car out.

Where the road dips near the Perryville Town Hall, a woman drove her vehicle into several feet of rushing water. She opened her car door to escape and was immediately pulled under. Fortunately for her, volunteer firefighters witnessed the near-drowning and were able to pull her to safety.

Also of particular concern were the bridges strung in close proximity below the dam. First was the JFK Highway (I-95) bridge that was not yet ten years old, as well as the World War II–era Route 40 bridge. There were also two major train bridges operated by the B&O and Penn Central. If the dam gave way, the loss of the bridges would be a serious blow to transportation up and down the East Coast.

In Port Deposit, state police kept watch over two barges moored at Wiley Manufacturing in town as the flood rose. The barges were loaded

with more than twenty-five thousand tons of steel subway tunnel sections awaiting shipment to New York City. If the barges broke free and were swept downstream, they might demolish the bridges below. If the barges got loose, troopers were to radio a warning, and all bridges downstream would be immediately shut down.

The water reached a record crest of 111.5 feet behind the dam. The floodgates were releasing seven million gallons of water each minute, and the flood gauge below the dam registered a record 36.85 feet. Not even the famous flood of 1936 had come close to that.

As everyone wondered what might happen if the dam broke or overflowed, a local newspaper photographer named Jim Cheeseman took an amazing photograph of the water rushing through the floodgates, filling the air with spray for hundreds of feet. Eyewitnesses said the water was nearly black with silt and mud. The sight of all that water and the threatened dam drew hundreds of curious onlookers, who watched the drama play out from high ground. And then, a horrible sight appeared as down the swollen, angry river came a rowboat with a man aboard. He shouted for help and waved his arms, but there was nothing they could do as the small boat was swept toward the dam. The boat was sucked down through a roaring floodgate, and that was the last that was seen of the man until his body turned up weeks later.

When residents returned to Port Deposit, some using rowboats and canoes to navigate to their homes, they found a sea of mud and debris left behind. But not a single life had been lost, aside from the man in the rowboat. Police announced a curfew in the empty towns and flood-damaged areas, but some looting did take place by what a local paper described as "human vultures." The humid June air smelled of mud and mildew as the flood receded.

In Maryland, almost every county—and Baltimore City—was declared to be a disaster area. A total of twenty-one deaths was reported in Maryland. Fifty died in Pennsylvania. Drowning was the primary cause of death.

While Conowingo Dam ultimately held, the flood held tremendous consequences for all who lived near Chesapeake Bay.

In his wonderful book *Bay Country*, journalist Tom Horton would describe Agnes as a "once in 500 years" storm. The sheer volume of water that had come down the Susquehanna River was unprecedented in modern times. Or as one Tolchester resident put it to me, "Everything on the bottom came to the top. It ruined the bay for years." Such was the storm's magnitude that the name was officially retired.

The vast amount of fresh water changed the salinity of the bay, affecting the populations of crabs and oysters far, far south of Conowingo Dam. But

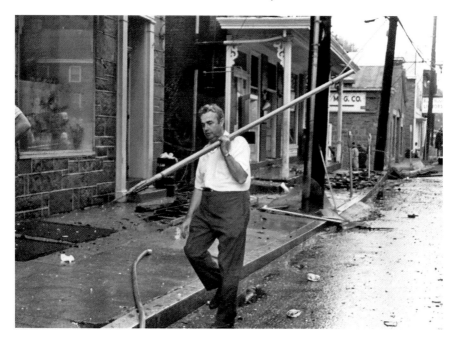

A Port Deposit resident makes his way through the wreckage and debris after the devastating flood brought on by Tropical Storm Agnes. *Courtesy Historical Society of Cecil County.*

even more so than the influx of fresh water, by far the worst impact on Chesapeake Bay came in the form of mud and silt. Untold amounts settled out of the water and covered the bay floor. Bay grasses that were home to spawning fish and crabs were smothered. The bed of the Chesapeake was a barren, silt-covered mass. According to a climate change report from the Chesapeake Bay Program, half of all the sediment deposited in the northern Chesapeake Bay between 1900 and June 1972 was from Agnes. In some ways, the Chesapeake is still only beginning to recover from this massive storm.

# TO HELL AND BACK AGAIN WITH HURRICANE HAZEL

*The wind*
*only*
*I am afraid of*
—*Frances Densmore, from a Native American song*

You can still find a few old-timers who will share stories about one of the biggest hurricanes in living memory to strike the Chesapeake Bay. Her name was Hazel, and by the time she finished roaring through in the early autumn of 1954, trees would be uprooted, roofs ripped off and the crabbing industry devastated. As it would turn out, three hurricanes would reach the Chesapeake that year—the other two were Edna and Carol—but it was Hurricane Hazel that left a lasting impression on the region.

Although hurricane-hunter planes were flying by then, meteorologists more than half a century ago still had only a rudimentary understanding of these great storms. As a result, Hazel's wrath would catch many in the mid-Atlantic region by surprise before the storm steamrolled north to become one of Canada's deadliest weather events. While forecasters knew the storm was approaching, it was generally expected to weaken greatly as it came ashore. As events would prove, that would not be the case.

The storm arrived in October, at a time when the weather is usually some of the best on the Chesapeake Bay, with golden early autumn days, blue skies and beautiful sunsets. But during those first two weeks of October, the

weather in the Chesapeake had been unseasonably hot and humid, with temperatures in the nineties. It was as if a bit of the tropics had decided to vacation in Maryland. Little did Chesapeake residents know that the hot, steamy weather would serve as a portent that a tropical cyclone was brewing thousands of miles away off the coast of Africa.

The storm that would become known as Hazel was first spotted on October 5 not far from Grenada. The storm track was difficult for forecasters to predict, proving them wrong as the storm not only grew in intensity but also took a series of turns that brought it ever closer to the United States.

Just before the storm finally made landfall on the morning of October 15 in the Carolinas, hurricane hunters measured the wind speed at 140 miles per hour, making it a massive and powerful Category 4 storm. By then, the clouds from the huge storm had already reached as far north as Pennsylvania, casting a shadow across the region.

The weather had been still and humid, but the wind soon began to pick up as the storm marched closer. In Norfolk, Virginia, at the entrance to the bay, sustained winds of 78 miles per hour and gusts of 100 miles per hour were measured. Baltimore soon had sustained winds of up to 74 miles per

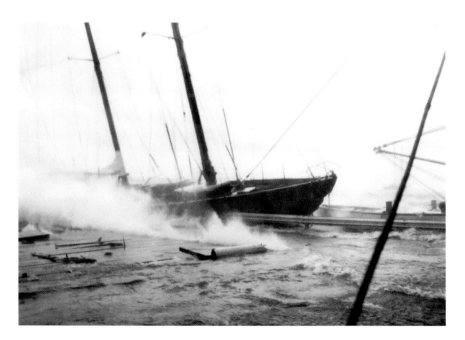

The USS *Vamarie* is shown being pounded against its dock in the Severn River at Annapolis, Maryland, during Hurricane Hazel on October 15, 1954. The training vessel sank during the storm. *Courtesy Naval Historical Foundation.*

hour as the storm struck the Chesapeake region. Talbot County reported a gust of 108 miles per hour. In Philadelphia, gusts of up to 100 miles per hour were recorded. As the storm traveled up the coast, it battered New York City, buffeting the Big Apple with high winds. A gust was recorded at Battery Park of 113 miles per hour, the highest on record for the city.

Winds of that intensity for a sustained period are extremely damaging. Stately trees were ripped from the ground, and many homes lost roofs or suffered wind damage. (When all was said and done, the storm would cost the Maryland and Washington, D.C. area about $22 million—an amount that would be multiplied several times over in today's dollars.)

Winds did not cause the only damage. Hazel brought a storm surge and very heavy rain to the region as well. According to NOAA, six to twelve inches of rain fell in western Maryland, causing severe flooding there. Tides reached two to six feet above sea level on the Chesapeake. The resulting flooding in Baltimore filled the streets. Waves churned up by the high winds and carried by the flood tide pounded the shoreline and docks. Even at the

Rescuers save a man caught in a flooded creek near Rockville, Maryland, in July 1975. *U.S. National Weather Service Collection.*

United States Naval Academy in Annapolis, the storm severely battered training vessels and sailing yachts that had been secured in advance against the storm. Elsewhere, closer to the open water of the lower bay, the storm surge swept away docks. Small craft broke free and sank. Wind and waves battered larger vessels into splinters.

Experts now say the storm was very deadly for that time, resulting in as many as ninety-five deaths in the United States. Overall, in Virginia, the storm was blamed for eighteen deaths—including four who perished when a tugboat capsized in the James River. An estimated eighteen thousand homes there were damaged. Half of all the electric and telephone lines in the state were downed by the storm winds.

The devastation was almost as bad in Maryland. NOAA reports that six Marylanders died as a result of the storm and several more were injured. (An additional three people were killed in the District of Columbia.) While most of the damage to homes was caused by wind, some houses close to the water literally washed away. The tidal surge and winds essentially wiped out the Eastern Shore's crabbing industry, and crab pots left in the water before the storm were a total loss.

Roads and bridges in the flood zone required expensive repair or replacement once high waters receded. Approximately half a million trees were downed. Maryland's apple and tobacco crops—still important state industries back then—sustained terrible damage just at harvest time.

Hazel had expended a great deal of its energy in the Chesapeake region, but the storm was far from down and out as it rolled northward. The hurricane would have blown itself out, but during the night the storm united with a cold front coming down from the Midwest and was reenergized. With renewed force, a monsterized Hazel struck Canada with hurricane-force winds of up to ninety-three miles per hour. The flooding and wind damage were extensive in Ontario. By the time Hazel finally dissipated into gusty winds and rain, at least eighty-one people had been killed in Canada by the hurricane.

On its official site, the National Weather Service lists Hurricane Hazel as one of the top ten weather events of the twentieth century to impact the Baltimore region. Even today, more than fifty years after that fateful day, Hurricane Hazel remains one of the benchmarks against which any great storm of the Chesapeake is measured.

# THE DAY THE *MARVEL* WENT DOWN

*There was a wailing in the shallop,*
*Woman's wails and man's despair,*
*A crash of breaking timbers on the rocks so sharp and bare*
*—James Greenleaf Whittier, "Swan Song of Parson Avery"*

When the *Levin J. Marvel* tourist ship set sail from Annapolis in the summer of 1955, tragedy was the last thing on anyone's mind. The twenty-three passengers and crew of four were taking a leisurely sail around the Chesapeake Bay over the next few days, stopping at various Eastern Shore ports to stroll the streets. Basically, they were enjoying summertime on the Chesapeake aboard a rustic old sailing vessel.

But a looming hurricane would change their idyllic cruise into a nightmare. Within a few days, the ship would be lost, fourteen people would drown in the stormy bay and a Coast Guard inquiry into the shipwreck would be launched.

The *Marvel* was an old, old wooden ship that continued to ply the bay when others like it from an earlier era had long since been left to rot. Built in 1891 in North Carolina, the ship was a three-masted "baldheaded" ram-type schooner, 125 feet long but just 24 feet wide. The ship had been rebuilt in 1919 and again in 1926, according to Coast Guard documents.

At least one newspaper described the *Marvel* as a familiar sight on the bay, and to be sure, it stuck out because of its ungainly appearance. The ship was designed with such a narrow beam because it carried freight (mainly lumber, grain and fertilizer) up from Virginia and the Carolinas to Philadelphia and

Summer storms over the Chesapeake can be dramatic—and dangerous. The photographer has caught a lightning bolt searing the sky over the bay. *Photo by Lauren Garvin.*

back again, transiting the narrow Chesapeake and Delaware Canal. The overall visual effect was of a long and narrow vessel, almost like a sailing canoe, with steep wooden sides. It was a workhorse rather than a yacht. In the wake of the disaster, one fact would become clear: the sixty-four-year-old *Marvel* was a ship far past its prime.

By the late 1940s, the ship had already served its original owners for more than five decades. But the *Marvel* had no engines and still relied on sail, a mode of transit that times had passed by. Barges and tugs had become the preferred mode of freight delivery by water.

And so the *Levin J. Marvel* passed into the hands of Herman Knust, who saw an opportunity to make the ship into a vacation cruise vessel. The vessel was re-outfitted into individual staterooms for tourists. Nothing too fancy—the rooms had bunk beds—but there were lights and running water in the rooms. A reporter and photographer from *Life* magazine even went aboard in 1946 for a story about taking the ship from Baltimore to Miami.

In 1954, the ship was purchased by John Meckling, a former Indiana resident who had studied law but whose real passion was sailing. Meckling was in his late thirties, charismatic and outgoing. At least one person described him as looking like the actor Ronald Reagan. Meckling soon

established Chesapeake Windjammer Vacations of Annapolis. The idea was to take vacationers on weeklong cruises around the bay.

"Beneath billowing sail," read one brochure described in a 2003 *Washingtonian* magazine article, "the clear moonlight making a phosphorescent wake which gleams like a ribbon of diamonds, your sailing cruise will be an event long remembered. Witness the beautiful sunrise and sunset on the Chesapeake. Storybook adventure, the nostalgia and romance of a sailing vessel awaits you." Advertising copy was one thing; reality was another. The ship that greeted guests inspired mixed emotions. Some who arrived for their vacation were turned off by the condition of the ship and left before it set sail. Others must have seen it as an adventure.

That particular week in August, the weather for the ship's voyage was rainy and overcast, putting a damper on some spirits. But then the sun came out, and the stars at night, so that the wake did indeed gleam "like a ribbon of diamonds."

During the week of August 8–12, the itinerary was as follows: depart Annapolis from the city dock, then visit Poplar Island, Oxford and Cambridge before heading for home port. From today's perspective, it seems like an enjoyable and fairly safe cruise.

Threatening to spoil the fun was Hurricane Connie. Connie was hard to read. She headed first one way and then another. The storm had reached Category 4 status far to the South in Puerto Rico, with sustained winds of 145 miles per hour. Since then, the storm had quickly diminished, and its path was hard to predict. The result was a conflicting and confusing weather forecast. At first, hurricane warnings were issued for the lower Chesapeake Bay. But by the time the *Levin J. Marvel* made its fateful run across the bay, the local forecast was for winds of just 15 to 30 miles per hour. If anything, the forecast called for ideal sailing weather. However, there remained the threat of a nor'easter-type storm as a result of Connie, and warnings were issued accordingly. Keeping in mind that the voyage took place nearly sixty years ago, the captain did not have the advantage of up-to-the-minute forecasts on his smart phone.

That Friday morning dawned with beautiful blue skies. Connie seemed to have changed course again and would spare the middle reaches of the Chesapeake. When the leading edge of Connie did reach the bay, the ship would already be back at the dock in Annapolis.

The *Marvel* set out from Cambridge, down the Choptank River and back into the open water of the bay. A storm-warning flag flew from the Cambridge Yacht Club as the *Levin J. Marvel* sailed by. No one on board seemed alarmed by the threat of a storm. In fact, the ship anchored for two

A Red Cross hurricane drill conducted in September 1958 in a church basement. Perhaps due to cold war threats, in that era disaster drills and shelters were more commonplace, and storm preparations were taken seriously. Baltimore Sun *photo by Clarence R. Garrett. Used by permission.*

hours near Hambrook Point in the Choptank so that the passengers could go swimming. It was time lost that the ship might have used to outrun the approaching storm.

At first, the weather couldn't have been any better. Even the official Coast Guard investigation reported: "The *Marvel* got underway at about 1630 hours 11 August 1955 and proceeded down the Choptank River toward the Bay, entering the waters of Chesapeake Bay at about 2040 hours 11 August 1955; she then proceeded northward up the Bay, under sail, the weather being fine and clear with a gentle northeasterly breeze, slight sea and swell."

One of those on board for the trip was deckhand Stephen Morton, just seventeen years old, an Annapolis resident. "We heard the hurricane was sort of marking time," he told an *Annapolis Capital* reporter right after the storm. "And we also knew a north-easter was due on the bay sometime today, but we thought we would be back in Annapolis before it hit."

The situation changed very rapidly as the fast-moving storm swept up the Chesapeake. The blue skies quickly gave way to a wall of clouds, followed

by gusting winds and rain. The sailing vessel soon found itself laboring in heavy seas in the middle of the bay, surrounded by miles of open water. As hopes of reaching Annapolis faded, Captain Meckling opted to make a run to Poplar Island to shelter on the lee side. It was a good plan, but the storm had become too intense to maintain that course. Instead, Captain Meckling opted to run for the safety of Herring Bay on the western shore. By then, the ship was running before the wind into a white wall of water and spray.

Though the ship had only sail power, it did have a small motorboat or yawl to help it maneuver. But according to Morton, the storm soon rendered the yawl useless: "Then the water pump on the yawl clogged up, and the motor went dead. We had to depend entirely on sails after that. I think we would have made it if the yawl hadn't gone dead."

The *Marvel* did manage to reach Herring Bay and anchored in the lee of a sandbar that helped create some protection from the oncoming waves. The ship was about one and a half miles off shore, where the water was about twenty-two feet deep. The sight of land and even distant houses was heartening to passengers. Between blowing sheets of rain, they had glimpses of the community of Fair Haven, a summer resort several miles south of Annapolis.

But the storm grew worse. As the ship lay at anchor, waves pounded it relentlessly. The yawl broke loose and was lost. The ship began to fill with water. According to the Coast Guard investigation, one of the key culprits was the fact that the porthole windows wouldn't close properly to keep out the water. With each wave, water rushed in. The weight of the water caused the vessel to settle lower into the bay. Sometimes the bow stayed under for several seconds when a big wave hit. For all on board, it became clear that it was only a matter of time before the *Marvel* went down.

"The water started coming over the deck and the forward pumps wouldn't work," Morton said. "We got a hand pump and started using that, but the water was coming in quicker than we could pump it out. We got life preservers on everything and took them on the aft deck. It was surprising how calm the passengers were. We started to tie a lifeline to everybody, but before we could do it a big wave came along and laid the boat on its side."

When that wave struck, it was all over for the *Marvel*. The old wooden ship lay on its side, foundering in the waves and lashing wind. The passengers and crew grabbed whatever they could to stay afloat. Some of those lost must have been trapped below when the ship rolled and never got out.

"I was tied together in a group of five," Morton recalled. "We could see land about three miles away, and we tried to get in. We would get in pretty

close to shore and could touch bottom. Then a big wave would pick us up and take us out again. The wind was blowing toward shore but the tide was going out. Finally we made it to a duck blind." Another passenger had floated there as well and had crawled into the blind. Freezing now from hypothermia, some people ripped tar paper from the walls and wrapped themselves in it. But the duck blind was swaying badly in the waves and now overloaded with survivors. Their temporary sanctuary now seemed perilous.

By some miracle, at least one survivor had washed up on shore and made her way to a house. She shared her story before passing out from the effects of exposure and exhaustion. Maryland State Police and the local volunteer fire department were alerted.

A crowd was now gathering on shore to see what they could do to help. The duck blind was within sight of shore, and someone saw the people inside—and their precarious position. Risking their lives, two young men borrowed a fourteen-foot boat with an outboard motor and set off for the duck blind. It took them three trips to get all the survivors off. The last one to leave the blind was Captain Meckling. Minutes later, the blind collapsed into the waves.

Helicopters now searched the water, and other rescuers combed the shore for survivors. A few did wash up, but so did bodies. Wreckage was strewn along the shore, but it was apparent that the old ship had been pounded to pieces. A police officer at the scene said, "I didn't see a bit of wreckage bigger than a door. She must have taken a terrific beating."

Two days after the ship went down, the last body was found, that of a thirteen-year-old boy. His father and mother, along with his nine-year-old sister, had all died in the shipwreck.

In addition to the *Levin J. Marvel* tragedy, Connie caused its share of destruction around the Chesapeake region. The storm passed directly over Washington and Baltimore before sweeping up into Pennsylvania. Outside D.C., five exchange students from Thailand perished when their car skidded off a wet road and into a flooded creek. As much as ten inches of rain fell along both shores of the bay. Along the oceanfront, waves and wind carved two new channels across Assateague Island. As the storm moved north, it was particularly destructive in New England, where it caused severe flooding. In fact, the name Connie was retired because of the scope of the 1955 storm.

In the weeks and months that followed, there would be a lengthy Coast Guard investigation into the loss of the *Levin J. Marvel*. The findings would indicate that the sinking was due to the poor condition of the ship, as well as

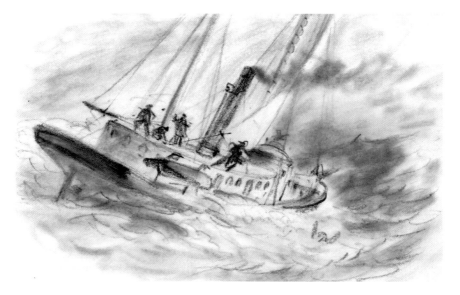

A sketch by newspaper illustrator Alfred Waud shows the drama as the crew of an early steam-powered tug tries to save a man who has fallen overboard in rough weather. In the days before lifejackets and basic rescue equipment, such mishaps often proved fatal. *Courtesy Library of Congress.*

questionable judgment in leaving a safe harbor in the face of storm warnings. But in many ways, the sinking of the *Levin J. Marvel* echoed the 1877 loss of the steamship *Express*—a ship ventured out onto the Chesapeake Bay during what appeared to be good weather and became overwhelmed by the sudden ferocity of a hurricane.

# CITY ON THE SAND

## THE LEGACY OF STORMS IN OCEAN CITY

*Safe upon the solid rock the ugly houses stand:*
*Come and see my shining palace built upon the sand!*
*—Edna St. Vincent Millay*

Ocean City is Maryland's summertime capital, a resort city where the population swells to nearly 400,000 on summer weekends. Tourists stroll the boardwalk or splash in the waves. It's a place for sun, sand and fun. It's also easy to forget that the sun hasn't always been shining upon this city on the sand.

People craving a bit of salt air and the feel of sand between their toes have been coming to Ocean City for a long time. The first beachfront cottage was built in 1869. Boardinghouses and hotels began to appear along the sandy spit between the sea and Sinepuxent Bay as the popularity of the destination grew. Eventually, a resort town was laid out with 250 lots on the land that was once owned by Englishman Thomas Fenwick, the original settler there. By 1875, the Atlantic Hotel had opened with four hundred rooms. There wasn't a boardwalk yet, but there was dancing and billiards to keep the guests entertained when they weren't at the beach.

The oceanfront resort continued to grow, but it was a vastly different town from the one we know today. It was much smaller, without the high-rises and development visible today. But one key difference was that it lacked the outlet to the sea that now exists. The resort was located on one long, sandy spit that stretched from Assateague Island to South Bethany and Fenwick Island, Delaware.

The storm-churned surf pounds a pier in Ocean City, Maryland. The resort town lives in uneasy proximity to the stormy Atlantic. *Photo by Tommy Lynch.*

The last really big storm to strike the oceanfront was in 1896. That all changed on August 23, 1933, when the Chesapeake-Potomac Hurricane roared into the region.

The Maryland and Virginia coast was no stranger to big storms. One of the largest seems to have occurred in 1821, when the region was only sparsely populated. From descriptions of the time, the storm was almost certainly a hurricane. It devastated both Assateague Island and Chincoteague. One account of that storm was recorded by none other than Howard Pyle. Though famous today as an artist, Pyle in his early career was an accomplished journalist who wrote articles to accompany his illustrations. He was a great fan of Delmarva history and wrote an article about Chincoteague for an April 1876 edition of *Scribner's Magazine*. His article describes the barrier island as a remote place occupied by rustic and hardy people who lived in rough shacks and made their living by rounding up the wild ponies or by fishing. Many drank heavily. He also describes the island people as kind and generous to visitors. Pyle was a natural storyteller, and he surely spoke with people who had lived through the storm or who had heard parents or grandparents talk about the hurricane. Unfortunately, in keeping with the breezy style of nineteenth-century travel writing, Pyle didn't bother to identify any of his sources or provide facts beyond what he gathered from listening to islanders' stories.

# The 1900s and Beyond

"Many traditions of the island are handed down from mouth to mouth by the natives, but few of them being able to read or write," Pyle wrote. From those stories, he pieced together a description of the storm:

*It is thus we receive a full account of the great storm and accompanying tidal wave of the year 1821; telling how the black wrack gathered all one dreadful day to the southeast; how all night the breathless air, inky black, was full of strange moaning sounds, and pine needles quivered at the forecasting hurricane that lay in wait in the southward offing; how sea-mews and gulls hurtled screaming through the midnight air; how in the early morning the terrified inhabitants, looking from their windows facing the ocean, saw an awful sight: the waters had receded toward the southward, and where the Atlantic had rolled the night before, miles of sandbars lay bare to the gloomy light, as the bottom of the Red Sea to the Israelites; then how a dull roar came near and nearer, and suddenly a solid mass of wind and rain and salt spray leaped upon the devoted island with a scream.*

*Great pines bent for a moment, and then, groaning and shrieking, were torn from their centuried growth like wisps of straw and hurled one against another; houses were cut from their foundations and thrown headlong, and then a deeper roar swelled the noise of the tempest, and a monstrous wall of inky waters rushed with the speed of lightning toward the island. It struck Assateague, and in a moment half the land was a waste of seething foam and tossing pine trunks; the next instant it struck Chincoteague, and in an unbroken mass swept across the low south marsh flats, carrying away men and ponies like insects; rushing up the island, tearing its way through the stricken pine woods.*

Pyle and the islanders he interviewed describe the wave as a "tidal wave" because a modern term like "storm surge" wasn't in their vocabulary. Fast-moving and awful, the storm tide racing ahead of the massive hurricane swept everything before its path. (A similar storm surge is described in terrifying detail in Erik Larsen's account of the 1900 Galveston, Texas hurricane in his book *Isaac's Storm*.)

Pyle's account continues:

*Many a time by the side of his bright crackling fire, the aged Chincoteaguer, removing his pipe from the toothless gums where he has been sucking its bitter sweetness, will tell, as the winter wind roars up from the ocean, how Hickman, with his little grandson clinging to his neck, was swept by the*

*great wave to King's Bush marsh, far up on the main-land six miles away, and caught in the tough branches of its bushes; or how Andrews, with wife and family swept away in his sight, was borne up the island on the waters, and the next morning was discovered hanging in a pine-tree, by his waistband twenty feet from the ground.*

Howard Pyle was not the only one to recognize the significance of the storm. Climatology expert Jeff Donnelly calls the storm of September 3, 1821, the biggest to hit the Chesapeake Bay region in four hundred years, surpassed only by the storm of 1667, which had long since passed out of living memory by the time Pyle reported his article.

For Ocean City residents, the storm of 1933 must have seemed almost as furious. At Assateague, waves twenty feet high swept in from the sea and over the dunes.

Ocean City's sandy spit has an elevation of just seven feet above sea level, so the barrier island was no match for the fury of the storm. Waves surged over the spit, deluging the town. The churning fury of the storm also carved an inlet between the sea and Sinepuxent Bay.

Storms sometimes have unexpected benefits. In 1933, the Great Chesapeake Bay Hurricane struck Ocean City, carving a new channel across the barrier island to the bay. The inlet has been improved and maintained and now allows boats easy access to the open ocean. This photograph was taken in the 1960s. *Photo by Mike Fitzpatrick.*

According to news accounts, the storm was devastating to other areas all around the Chesapeake Bay and Delmarva Peninsula. Six people died on the Eastern Shore as a result of the storm, many homes were damaged beyond repair and roads were destroyed. The *Eastern Shore News* reported the following on September 1, 1933:

> *Many families were driven from their homes. Some escaped in boats, others swam to safety while others floated on wreckage until rescued. Homes were flooded by salt water and the damage to furniture and household goods will run into many thousands of dollars. In many homes, windows and doors were battered down by the pounding waves. High winds did tremendous damage, felling trees, deroofing buildings, and destroying crops. Thousands of chickens and many horses, cows, sheep, dogs, and other animals were drowned.*

The storm surge completely covered Deale's Island, and coffins floated out of their graves. Salisbury in Wicomico County was safe from the sea but heavily damaged by hurricane winds.

Across Maryland, residents were buffeted by high winds. The storm had made landfall in North Carolina and then tracked across Virginia and into central Maryland. More than seven inches of rain were reported in Baltimore, which set a record. The weather was blamed for a train accident in Bladensburg, near Washington, D.C.

While the Chesapeake-Potomac Hurricane destroyed a great deal of property as it pounded Ocean City, the town's civic leaders actually were pleased that the storm had brought a gift in the form of the fifty-foot-wide inlet. For years, they had been calling for just such an outlet to be dug, but there never had been funds to undertake such a huge project. And here the hurricane had done it for them. In the years that followed, the U.S. Army Corps of Engineers widened and developed the inlet by adding a protective jetty. This outlet to the sea has enabled Ocean City to become not only a resort but also a major sport-fishing center. In the end, the Great Chesapeake-Potomac Hurricane had given Maryland's resort town an unintended gift that would help it to grow and become the city by the sea that it is today.

Three decades would pass before Ocean City was battered again by such a vicious storm. That came on March 6, 1962, when the resort town was hit by what became known as the Ash Wednesday Storm.

This was not a hurricane but a nor'easter that ravaged the East Coast, battering the Outer Banks and Virginia waterfront towns before hitting Ocean City. At that time, Ocean City had a year-round population of about 1,500. According to a recent *Baltimore Sun* article, the storm was one of the worst to hit the East Coast in the twentieth century, causing about $1.5 billion damage in today's dollars and resulting in forty deaths. "This is the worst disaster in the history of Maryland in my time," said Governor Millard Tawes, who took an aerial tour of the storm damage. "I've never seen anything like it. It was a horrible sight."

Winds reached sixty miles per hour and caused a storm surge of more than nine feet. The resultant high water rushed over the sandy spit on which the resort town is located. Waves ripped away the boardwalk and damaged up to seventy-five houses and businesses. Beach erosion was severe, with a swath up to 250 feet wide and 8 feet deep being washed away. Many of the houses and business that were lost had been located on this section of pummeled beachfront. Farther in, residents fled to upper floors as the streets filled with rushing water.

Experts say the building practices at Fenwick Island, Delaware, and other resort towns make them vulnerable to storms. The original sand dunes have been removed, leaving a flat sand spit with little shelter from the sea. The State of Maryland and the U.S. Army Corps of Engineers have undertaken beach replenishment projects as storms and tides carry off the sand. *U.S. Geological Survey photograph.*

The *Sun* reported that the storm had an unintended effect, which was to protect Assateague Island from development. Earlier, the barrier island had been subdivided into building lots, and at least one road had been paved. The massive storm washed away all the infrastructure, and developers deemed reconstruction to be too costly. Assateague National Seashore was then created.

While it is reassuring that Ocean City has survived its share of storms, the knowledge of what Mother Nature is capable of makes some uneasy, especially now that the resort is far more of a City on the Sand than it was in 1962. If the 1933 storm was powerful enough to cut an inlet and change the very character of the barrier island, could it happen again? The experts say a really big hurricane could alter Ocean City's geography once more or even wash its concrete towers and boardwalk back into the sea. That future remains to be seen, but it is understandable if Maryland's oceanfront city pays particular attention to the hurricane forecasts.

# IN THE DEEP MIDWINTER

## SNOW, ICE AND TRAGEDY ON THE CHESAPEAKE

*Where are the songs of spring? Ay, where are they?*
—*John Keats*

Winter in the Chesapeake Bay region can be a dangerous season. Blizzards can be hard and blinding, bringing all traffic on land and water to a standstill. On the other hand, snow can be a fickle visitor. It's not all that unusual for snow that falls during the coldest hours of the night to melt away to slush by noon, even under a wan winter sun. Those kinds of snows are a nuisance for morning commuters or might delay school for the day, but they are hardly the stuff of legend.

Every now and then, Mother Nature puts a real curve on that snowball. It's the kind of snowball that doesn't explode harmlessly in a burst of frosty crystals but hits so hard it knocks us down. It's a snowball that somebody has stuck in the freezer. Every now and then, there's a winter storm on the Chesapeake that packs a real wallop.

One of the worst recorded snowstorms in the region dates to colonial times, when the so-called Washington and Jefferson Snowstorm struck on January 27–28, 1772. These great men—avid weather watchers both—made notes in their diaries or journals about this storm, which left up to three feet of snow across Maryland and into Virginia. There were no official weather records yet, but we can probably take the accounts left by Jefferson and Washington at their word. Travelers were stranded for up to two weeks

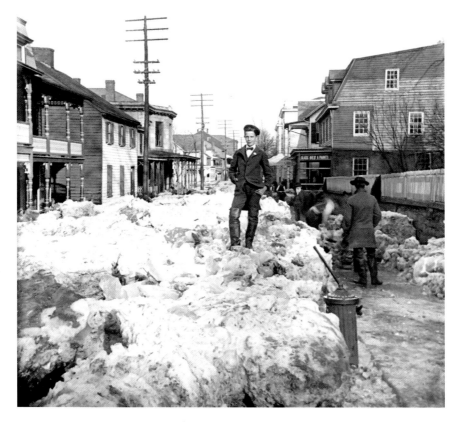

A young man stands proudly atop the piles of ice littering Port Deposit's streets on February 11, 1904. An "ice gorge" created a kind of dam on the Susquehanna River during an unusually cold winter, causing the river to overflow and carry chunks of ice through the town streets. *Courtesy Historical Society of Cecil County.*

by the impassable roads. Commerce and the mail came to a standstill. And, of course, America was still a colony of England.

For the next century, there were more than a few notable snows and storms. While the great blizzards of 1888 and 1899 were some of the biggest snowstorms ever to strike the Chesapeake Bay region, winter always seems to return with a vengeance, trying to outdo itself whenever possible. And sometimes it's not the intensity of the storm or the depth of the snowfall that matters so much as what happens during the storm. For instance, the well-known Elkton Academy burned to the ground during a snowstorm in 1854.

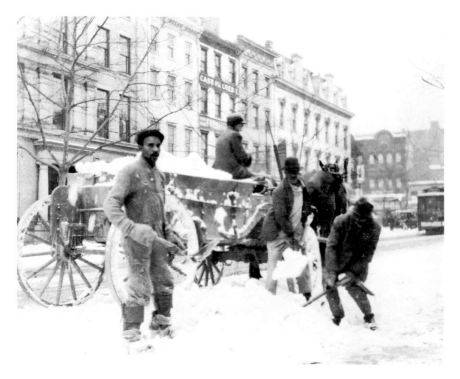

Cleaning up after a big storm was once back-breaking work done with shovels and horse-drawn carts, as shown in this photograph of a street crew at work in the nation's capital. *Courtesy Library of Congress.*

On occasion, the detailed reports from the Maryland Weather Service about snowfall in the Chesapeake Bay region drew attention from surprising and unlikely sources. Consider this anecdote published in 1894 in the pages of the *Quarterly Journal of the Royal Meteorological Society*, which seemed captivated by the calculations regarding a snowfall on our side of the Atlantic:

> *The Weight of Snow.*—*Prof. Cleveland Abbe, in the* Monthly Weather Review *for April, gives the following notes on the weight of snow:*—*"In connection with the heavy snowfall of April 10th and 14th, in Pennsylvania, N. 41°, W. 77° 40", the amount of snow that fell on the platform scales at that place weighed 1,640 pounds; as the platform was 8 by 12 feet, or 96 square feet in area, this gives an average weight of about 17 pounds to a square foot, which is equivalent to a depth of 3.3 inches of water, and using the ordinary ratio, 10, this gives a corresponding depth of 33 inches of snow."*

# The 1900s and Beyond

*Mr. Edward Ferry, of Bel Air, Harford Co., Md., in a letter published in the monthly report of the Maryland State Weather Service, states that his clerk found that the weight of the snow on the platform scales at that place was 1,520 pounds (presumably on the morning of April 12th); the scale platform measured 7 feet 10 inches by 15 feet; this gives an average of 12-93 pounds to the square foot, and, if we assume that none of the snow melted, and so escaped being weighed, this would correspond to a depth of 2–4 inches of water. The average depth of snow lying on the ground at the end of the great snowstorm of April 10th and 11th, in Northern Maryland, varied from 15 to 30 inches in the different localities covered by newspaper reports, but the largest recorded by regular observers was 24 inches at Darlington and at Fallston, both in Harford County, at the head of Chesapeake Bay.*

*Although the above result may be rather crude, yet it suggests an excellent method of getting at the average quantity of precipitation in case the snow falls without melting and without much drifting. It also gives some idea of the weight that must be supported by roofs and walls in cases of similar heavy snowfalls.*

On January 28, 1922, 98 people died and at least 133 were injured when the Knickerbocker Theatre in Washington, D.C., collapsed under the weight of a huge snowstorm, from then on known as the Knickerbocker Storm. *Courtesy Library of Congress.*

In the twentieth century, another storm was known for a deadly fire. A big blizzard struck the region on February 20, 1934, during the Great Depression era. The *Philadelphia Record* reported, "The Atlantic seaboard from Maryland to New England was caught yesterday in a frigid grasp of snow and ice after the worst snowstorm in years." The tragic fire in the wake of that huge storm struck at the Pennsylvania Memorial Home for the aged and infirm, where ten elderly women perished and efforts to fight the fire were hindered by the weather. In addition to the fatal fire, the storm caused twenty-six deaths in the region, the *Record* reported. Many roads in the upper Chesapeake Bay and northward had four or five feet of snow covering them.

The impact of the 1934 storm was felt hard at sea. The nor'easter's winds reached sixty miles per hour along the coast. Two cod fishermen from Atlantic City had to be rescued by the Coast Guard. Jacob Driscoll, forty-three, and his nephew, Harold, eighteen, had set out in a thirty-foot open skiff when they were caught by "mountainous seas," and their gasoline ran out eight miles from shore. Their survival was deemed a miracle. Two ships foundered off the New England coast.

Winter struck again in 1958, and it almost seemed unfair, considering that the deep snow came in late March. It was an incredible snowfall, with measurements of 42 inches coming in from residents near the Susquehanna River in Maryland. The town of Elkton at the very top of the Chesapeake Bay was buried under 37.1 inches of wet, crushing snow. That measurement was taken by H. Wirt Bouchelle, who had been a postal carrier since 1908 and an official National Weather Service observer since 1927. Bouchelle had recorded 76 inches of snow that winter—though half the total had come from that single March storm.

The massive storm left communities in the upper Chesapeake Bay region without power for twelve hours. Power companies from neighboring states sent men to help, so that a crew of 186 linemen was working around the clock to restore electricity. It was noted that not even Hurricane Hazel four years before had caused so much damage. At Losten's Dairy in Chesapeake City, the power was out for a week, and the dairy relied on a generator.

The deep snow proved dangerous and, in some cases, deadly. There was a close call at the Chesapeake Boat Co., where the marina owners had just been inspecting a boat shed that measured 95 feet by 136 feet, under which thirty boats were sheltered on the Elk River. Other than some creaking and groaning, there was no sign of any cause for concern. Ten minutes later, the two men were inside their office having coffee when a tremendous crash caused them both to leap to their feet. The entire shed under which they had

Deep snow made travel conditions challenging for Chesapeake region motorists in February 1958. *Courtesy Historical Society of Cecil County*.

just been walking had collapsed. Loss of the yachts and shed was estimated at nearly $300,000.

Others weren't so fortunate. A farmer near the town of Rising Sun who ventured out to check on his barn, flattened by the great snow, died when he stepped back onto his front porch and the roof collapsed.

At Conowingo Dam, a young U.S. Navy WAVE was killed and three other military women were injured when their car careened out of control on the icy road and went through a guardrail. Their car fell ninety feet before landing at the base of the dam. The women had been returning to the Bainbridge Naval Training Center the night of the storm.

While the snowfall of 1958 was one for the record books, it wasn't the only notable storm of the twentieth century. Two back-to-back years of big storms arrived in 1978 and 1979. The Blizzard of '78 struck the Chesapeake region, leaving eighteen inches of snow in Havre de Grace. The storm was devastating as it moved into New England, leaving more than two feet on Boston roads. Then, on February 18–19, 1979, came the Presidents' Day Blizzard, which left as much as twenty-six inches of snow across much of Maryland. The snow fell very quickly, sometimes at the rate of up to three inches per hour. With the snow came extreme cold that made conditions even more brutal.

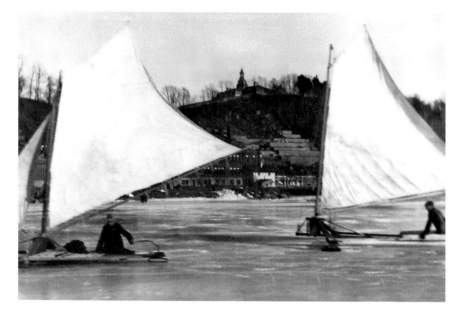

The frozen Susquehanna River was the scene of ice boat races in the early 1900s. *Courtesy Historical Society of Cecil County.*

The Blizzard of 1983 dumped at least twenty-two inches of snow in the Baltimore area. Schools were closed in many parts of the state for up to a week.

In 1996, a huge storm struck on January 7 and buried much of the Eastern Shore under two feet of snow or more. The storm was followed by warm temperatures that melted the snow so quickly that tremendous flooding resulted on the Potomac and Susquehanna. Then, on February 16, snow returned with a storm dropping yet more snow, making this one of the snowiest winters in some time on the Delmarva Peninsula.

The record stands with a more recent winter. In 2009–10, back-to-back storms left the Baltimore area covered in 72.3 inches of snow, surpassing all winters since records began being kept in 1893. According to the *Washington Post*, the previous record winter for that city was set in 1898–99, when 54.4 inches of snow fell. The 2009–10 storms left behind 54.9 inches of snow in the capital.

# ISABEL SURGES INTO CHESAPEAKE

*All day the wind blows*
*And the rock*
*Keeps its place*
*—W.S. Merwin*

On those first days of September 2003, Marylanders had a lot on their minds. The two-year anniversary was looming of the day when jets had flown out of crystalline blue skies into the World Trade Center, the Pentagon and a field in Pennsylvania, turning the world upside-down. Now, the United States was at war on two fronts in Iraq and Afghanistan.

Yet the weather still managed to make the news. In August, a tremendous heat wave struck Europe, sending the mercury to 112 degrees in Paris—a city where air conditioning was a rarity. In June, the largest hailstone ever recorded fell to earth in Aurora, Nebraska. It measured seven inches across and weighed nearly two pounds.

Closer to home, August and September had been hot and humid in the Chesapeake Bay region—not that this was unusual for late summer. There was news of a storm brewing off the coast of Africa and surging across the Atlantic. Hurricane Isabel reached Category 5 status far off the coast and then quickly lost steam to become a Category 2 storm. While the intensity of the storm had fallen off, the hurricane remained massive and powerful.

Chesapeake Bay residents could be forgiven if they viewed news of the approaching storm as just another case of media hype. In recent winters, it seemed as if every other snowfall was trumpeted as the "storm of the century,"

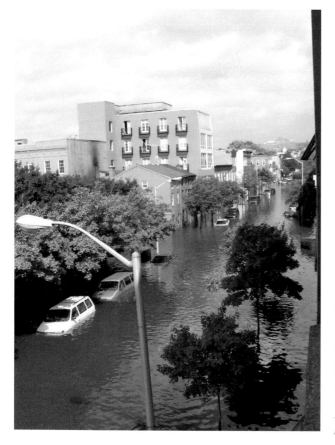

The storm surge from Hurricane Isabel in 2003 flooded many neighborhoods that were normally high and dry, including this Fells Point street in Baltimore. *Photo copyright Todd A. Carpenter. Used by permission.*

"snowmageddon" or some similar hyperbole that made for a nice sound bite and dramatic television graphics. News of a big hurricane headed toward the region seemed to fall into the same category and didn't cause much of a stir.

More than thirty years had passed since a major hurricane had struck the Chesapeake Bay. Among the most recent near misses had been Hurricane Gloria in 1985, which pretty much turned out to be mostly bluster in the Chesapeake region despite dire predictions. Then in September 1999 came Tropical Storm Floyd. That storm was mainly a rain event for the Chesapeake Bay region, dumping as much as twelve to fourteen inches within twenty-four hours. Yet aside from localized flooding, the storm caused little real damage in Maryland (though up and down the East Coast the storm did claim fifty-six lives, making it the deadliest since Agnes in 1972).

It didn't help matters that storm forecasts were now so far in advance. In the 1960s, track forecasts were issued just 72 hours or so before the storm.

# The 1900s and Beyond

In 2003, predictions of the hurricane's track were being made by NOAA up to 120 hours in advance—when the actual storm was still days upon days away. While the advance warnings are helpful, they tend to make the threat of a storm less imminent.

This storm looked to be much worse. Most worrisome of all was that experts predicted a trajectory that would bring Isabel just to the west of the Chesapeake Bay. Historically, the very worst storms had followed this same route. On a map, this looks to be a favorable path for a storm because the hurricane avoids a direct hit on the Chesapeake Bay. But the past paints a far different story about hurricanes that veer "just to the left" of the bay. While storms that hugged the Atlantic coastline may seem more threatening, it was almost always these more westerly storms that had wrought the most damage to Maryland, Virginia and Delaware.

In Virginia, TV meteorologist John Bernier warned viewers, "Thursday may be the most arduous day of your life."

The day before Isabel struck, the National Hurricane Center issued its 3:00 p.m. forecast:

> *A hurricane warning remains in effect from Cape Fear North Carolina to Chincoteague Virginia…including Pamlico and Albemarle Sounds…and the Chesapeake Bay south of Smith Point.*
>
> *A Tropical Storm Warning remains in effect north of Chincoteague to Moriches Inlet New York…including Delaware Bay. A Tropical Storm Warning remains in effect south of Cape Fear to South Santee River South Carolina…for the Chesapeake Bay from Smith Point northward…and for the tidal Potomac.*

With these dire words now being repeated on television and readily available on Internet news sites, the storm looming on the horizon seemed to be the real deal. There was a last-minute rush as residents took notice. Supermarkets were swamped with people buying canned goods, water and ice. Long lines appeared at gas stations as motorists filled their tanks. And at hardware stores everywhere, there was a run on plywood, chainsaws and generators. The residents of the Chesapeake Bay region finally had taken heed of the storm warnings. But would their efforts be enough?

The model for the storm indicated that areas at the top of the Chesapeake Bay would be the hardest hit as the storm surge drove massive amounts of water up the bay, forcing it back into tributaries, creeks and rivers—and towns and neighborhoods that were usually beyond the reach of high water.

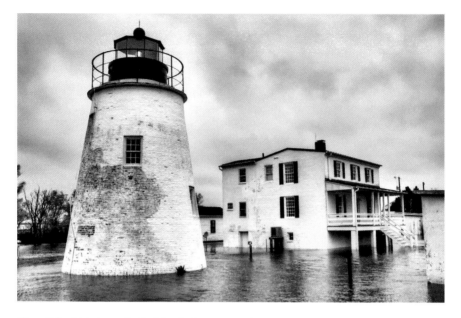

Piney Point Lighthouse in St. Mary's County stands surrounded by the storm surge from Hurricane Isabel in 2003. *Photo by Michael Milauskas.*

With dusk came the first smattering of rain. And then Chesapeake residents settled down to wait. There's something visceral about a storm in the night, how it tugs at the eaves and rattles the windows like some beast trying to get in.

By morning's light, it was obvious that trees were down everywhere. The tide had risen as much as eight feet, and waves had actually battered some waterfront homes. Entire houses had been washed away in some waterfront areas. That was unheard of in the upper Chesapeake. Nothing like that had happened in anyone's lifetime. While the loss of houses was devastating and the lack of power was inconvenient, officials stated that no one had been injured.

Across the region, other communities were taking stock and picking up the pieces. An estimated eight thousand houses in Virginia, Washington, D.C., and Maryland had been damaged or destroyed by the storm. Countless trees had been lost, and the downed power lines that resulted left two million residents in the dark. The power outages would last for days in some cases, especially for houses that were down country lanes or otherwise off the main roads.

In Fells Point and Annapolis, curious kayakers explored neighborhoods now under several feet of water. The United States Naval Academy campus experienced flooding and resultant damage. In the D.C. area, Georgetown

Hurricane Floyd in 1999 caused its share of damage around the Chesapeake region. High winds blew an old communications antenna around power lines near the town of Marion in Somerset County. *Courtesy Choptank Electric Cooperative.*

was under as much as 8.72 feet of water. The storm destroyed the wooden boardwalk along the Susquehanna River at Havre de Grace.

The Baltimore region received just one to three inches of rain, so the flooding was brought about strictly as a result of the storm surge. Inland areas weren't quite so lucky. In the Shenandoah Valley, NOAA reported that Isabel brought from six to twelve inches of rainfall as the storm passed directly over the region.

In the aftermath of the storm, officials assessed the damage, the forecast and preparation efforts. "Isabel is considered one of the most significant tropical cyclones to affect northeast North Carolina, east central Virginia, and the Chesapeake and Potomac regions since Hurricane Hazel in 1954 and the Chesapeake-Potomac Hurricane of 1933," noted David L. Johnson, assistant administrator for Weather Services at NOAA, in a report about the storm. "Hurricane Isabel will be remembered not for its intensity, but for its size and the impact it had on the residents of one of the most populated regions of the United States. Isabel is a reminder that if the impact of a Category 2 hurricane can be so extensive, then the impact of a major hurricane (Category 3 or higher) could be devastating."

# GOODNIGHT, IRENE

*Ramblin' stop your gamblin'*
*Stop stayin' out late at night*
*Go home to your wife and your family*
*Sit down by the fireside bright*

*Irene good night, Irene good night*
*Good night Irene, good night Irene*
*I'll see you in my dreams*
*—traditional folk song lyrics*

The most recent hurricane or tropical storm to impact the Chesapeake Bay region arrived in August 2011. The storm had originated off the west coast of Africa on August 15, steaming across the Atlantic as a large mass of thunderstorms and heavy clouds. Hurricane Irene entered the weather lexicon as a fearsome storm, striking the Bahamas on August 21 as a Category 3 hurricane with sustained winds of more than 111 miles per hour.

Forecasters warned that Irene had the potential to cause extreme damage if the storm did not diminish in intensity. Most worrisome was its track—the storm appeared to be headed directly up the East Coast just at the height of the summer beach season. Millions of residents and beachgoers now lay directly in Irene's path. Thanks to advanced forecasting, warnings and evacuation orders were issued as a precaution. Untold numbers of vacationers found their vacations cut short by the looming storm.

In some ways, it's hard for us to fully grasp the scope and power of a hurricane. A hurricane requires some imagination to take in its full scope and scale. It is one of nature's most massive storms in that, from space, its telltale spiral cloud system can cover a relatively vast portion of the North American continent. It's also a storm that usually begins in the warm waters of the West African coast and then travels across the Atlantic and on across the Gulf of Mexico or else northward into Canada. A hurricane is to storms what a marathoner is to runners. At the same time, it packs a wallop. If a hurricane were a baseball player, it would be a slugger like Babe Ruth. Most frightening of all are the human stakes involved. For all their fury, blizzards are fairly localized and have a limited cost in human lives because most sensible people seek shelter from the storm. Hurricanes strike highly vulnerable human populations in the Caribbean and then steam on to the coastal areas of the United States, inhabited by millions.

Our love affair with the coast is part of the problem. We insist on building vacation homes—and, sometimes, whole cities or resort towns—in known flood plains. Never mind that the last "big one" took place fifty or one hundred years ago. When it comes to storms, history has a way of repeating itself—and then some. Thus, when a hurricane hits, the storm strikes at the soft underbelly of coastal development.

Fortunately for East Coast residents, Hurricane Irene quickly faded and made landfall at Cape Lookout, North Carolina, on August 27. By then, according to NOAA officials, Irene was still a Category 1 storm with sustained winds of ninety miles per hour. And it was still a very large and lumbering storm. Irene skipped back out to sea and passed just offshore of the Delmarva Peninsula, pounding Ocean City and coastal areas with winds of up to seventy miles per hour and up to twelve inches of rain.

It could have been worse there. The *Washington Post* reported the Ocean City mayor as saying that the resort hadn't dodged a bullet but had dodged "a missile."

Irene struck shore again close to Atlantic City, New Jersey. As it moved northward and inland, the storm was far from spent. Just ask the residents of New Hampshire and Vermont, who watched as Irene's rains flooded hundreds of roads, swept away bridges and inundated New England towns. By most accounts, Irene caused the worst flooding there in eighty years. On August 30, Irene was "absorbed" by a front moving down from Canada. After roughly two weeks on the move, the storm's long, destructive journey was over. In the United States, six died in the storm surge or in rip currents, fifteen died due to the high winds (mostly a result of downed trees, although

An infrared satellite image of the Outer Banks, Chesapeake Bay and Delaware Bay. *Courtesy National Oceanic and Atmospheric Administration/Department of Commerce.*

one Queen Anne's County woman on Maryland's Eastern Shore was crushed by a collapsing chimney) and twenty-one died in floods caused by the heavy rains. A Virginia teen died in a traffic accident that officials said was caused by a traffic signal that wasn't functioning due to the power outages.

In terms of property loss, Irene was very costly to the region. "In the Hampton Roads area, and along coastal sections of the Delmarva Peninsula from Ocean City, Maryland, southward, storm surge flooding was comparable to that from Hurricane Isabel of 2003," NOAA officials wrote in their official report on the storm.

Elsewhere, downed trees were the culprit that left as many as 800,000 Chesapeake-area residents without power. Utility crews from other

Life on the water wasn't all about storms and danger. Men are shown here fishing for shad on the moonlit Susquehanna River, using a floating lantern to attract fish. *Courtesy National Oceanic and Atmospheric Administration/ Department of Commerce.*

states—some from as far away as Arkansas—poured in to help get the lights back on. Marylanders were among at least 6 million left without power by the storm. "The major disruption in infrastructure really is the power outages that we've been reporting," Maryland lieutenant governor Anthony Brown said at the time.

Those words fall short of capturing the real fury of the storm, which struck during the night. We listened to the wind howling and roaring and, at one point, ventured onto the front porch to watch the trees whip and the rain lash in the darkness. The lights flickered and went out. And for a little while, as the windows rattled and the trees creaked and groaned beyond, we were as helpless before the storm as residents on the Chesapeake must have been four hundred years before.

# THE GREAT DERECHO OF 2012

D erecho is a weather term one doesn't hear much in the Chesapeake Bay region. But after the great wind storm of June 29, 2012, it's a word no one will forget anytime soon. According to weather experts, derecho is a term coined in the 1880s to describe a peculiar weather phenomenon that produces a wall of wind and storm; some have described it as a hurricane over land.

While other areas of the country do experience a derecho-type storm at least once a year, it's very rare in the Chesapeake region. The one that struck in 2012 actually originated in the Midwest and charged all the way to the Atlantic in just about six hours. This was a vast, powerful storm that stretched across a front of about 240 miles. Experts say it was probably a long stretch of really hot weather that triggered this derecho.

Just before midnight, storm warnings were quickly posted online for the Maryland area of a storm with winds of up to eighty miles per hour. This seemed incredible to local weather watchers, and there was a relatively short time to batten down the hatches before the storm arrived.

Many who were up that Friday night and watched the storm come in later expressed awe at the constant lightning, almost like strobe lights wielded by giants. Then came a wall of wind and heavy rain, threaded through by lightning. Some headed for their basements because the roar of the wind reminded them of a tornado. They were not far wrong.

The derecho produced powerful straight-line winds that approached tornado speed. Gusts of sixty, seventy and eighty miles per hour roared across Virginia, D.C., Baltimore, Chesapeake Bay and the Delmarva Peninsula. Winds measured sixty-six miles per hour at the Chesapeake Bay

# The 1900s and Beyond

This massive tree came down in the unusual derecho storm of June 29, 2012, crushing a car in the historic Sudbrook Park neighborhood in Baltimore County. *Photo by Anne Lindenbaum Hoffman.*

Bridge Tunnel. A buoy in the upper Chesapeake Bay with a private weather station reportedly clocked a single wind gust of more than one hundred miles per hour across open water. It seems hard to fathom until one saw the wind damage. Trees came down everywhere, crushing cars, downing power lines and falling on houses. Millions in the mid-Atlantic region lost power, and some had no electricity for days.

A handful of people died as a result of the derecho in the Chesapeake region when they were killed by falling trees. One man perished when his boat capsized in the bay at the height of the storm.

In his weather blog for the *Washington Post*, meteorologist Jason Samenow wrote, "This derecho event is likely to go down as not only one of the worst on record in Washington, D.C. but also along its entire path stretching back to northern Indiana."

In the wake of the derecho, it was generally agreed that this storm caused more damage than a hurricane—usually the most-feared storm in the Chesapeake region. In the annals of the Chesapeake's great storms, it was the most recent entry in a list going back four centuries.

# A PERILOUS PAST,
# A STORMY FUTURE

*Climate is what we expect, weather is what we get.*
*—Mark Twain*

When it comes to predicting the future of storms on the Chesapeake Bay, one of the great question marks is the climate itself. In the pages of this book, there have been no shortages of gales, blizzards and hurricanes. Often, these storms have caused untold human tragedy, loss of life, suffering and phenomenal property damage.

How could it possibly get worse? In a word (or two): climate change. The subtle, quiet alterations wrought by shifting weather patterns and ever-higher tides bring their own quiet fury. If sea levels rise as predicted and ocean waters grow warmer, the reach and intensity of future storms could have a devastating impact on the Chesapeake region.

To understand this potentially stormy future, it helps to know something about the Chesapeake region's geological past. At 200 miles long, Chesapeake Bay forms the largest estuary in the United States. At its narrowest point near Kent County, the bay is a mere 4 miles wide, yet its waters span nearly 30 miles at the mouth of the Potomac. The bay drains more than 64,000 square miles from at least 150 rivers and streams that flow into it. Some rivers are mighty and temperamental, as the Susquehanna, and some streams are mostly trickles. The bay has 11,684 miles of shoreline. Those mere numbers don't do its scope and scale true justice. Perhaps Captain John Smith came closest when he said of the Chesapeake, "This is a noble sea. Calm and hospitable, majestic in size. Its potential cannot be imagined."

Ice is the "quiet storm" on the Chesapeake Bay and its tributaries, causing all sorts of problems for vessels trying to navigate the icy winter waters. *Courtesy Historical Society of Cecil County.*

At the heart of the Chesapeake is a drowned river valley, flooded ten thousand years ago by the melting of the last great ice age. Though the massive sheets of ice never reached as far as Maryland, the melting of the glaciers to the north helped to create what we now know as the Susquehanna River.

To put things in perspective, it's helpful to keep in mind that European settlement of the Chesapeake began four hundred years ago—just a blip in the Chesapeake's long history. And if one goes back even further, scientists say the Chesapeake really got its start thirty-five million years ago when an asteroid struck the earth just about where Cape Charles is located today, creating an impact crater the size of Rhode Island and rolling out a tsunami that swamped the distant Blue Ridge Mountains. In that instant, the geologic fate of what would become the Chesapeake Bay was decided.

Asteroids, ice ages and storms themselves are all far beyond human control and a reminder—however remote a possibility it may seem as one strolls along the beach on a fine day—that our human existence may be more fleeting and tenuous than ever we thought. It may be the ultimate act of hubris to believe that humans even matter in terms of environmental change or their lasting impact on the planet.

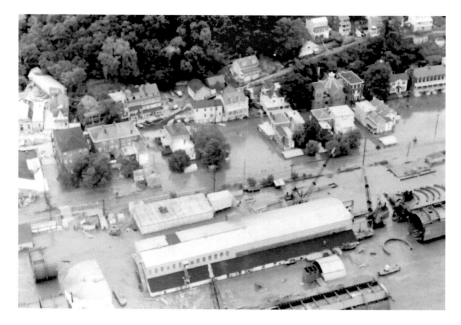

The flooded streets of Port Deposit, Maryland, in June 1972. It was some of the worst flooding that the historic waterfront town had ever seen. *Courtesy Historical Society of Cecil County.*

The past shows us that storms up and down the East Coast can be massive and unpredictable. And as it turns out, this past has an important role in predicting the future of storms. In recent years, an interesting branch of science has evolved that involves the study of historical storms. Called paleotempestology, this study of ancient storms provides an indicator of what we might expect in the not-so-distant future. By the end of this chapter, you may have an urge to batten down the hatches and head for higher ground.

Slogging through the seldom-visited marshes surrounding some of America's most populated areas, these hunters of ancient storms drive metal probes deep into the muck and mire to extract core samples. Taken back to a lab and analyzed, these samples can give clues to past flooding brought on by super storms that may have taken place long before there was any written record of the weather in North America. It's a fledgling science with a practical application. Through the study of the frequency and scope of ancient storms, paleotempestologists are better able to predict what sort of stormy future may be in store. While insurance actuators everywhere salivate at the thought of being able to predict the size and scope of storms, in reality it remains hard to pinpoint how often storms will occur or how severe the worst of those storms will be.

There have been some interesting predictions. The *New York Times* recently reported that climatologists had found the Atlantic is now in a warmer era, which means hurricanes may be more frequent in the next few decades than they were from 1970 to 1994.

Researchers have shown that the most powerful hurricanes are actually quite rare. Just two Category 5 storms have pounded the United States in the modern era: Hurricane Camille in 1969 (primarily a Gulf Coast event) and the unnamed storm that devastated the Florida Keys in 1935 and was graphically described in spare prose by Ernest Hemingway. That's not to say that lesser storms aren't dangerous. In 2005, Hurricane Katrina struck the Gulf Coast as a Category 3 storm, devastating New Orleans and leaving more than 1,800 dead. The 1900 Galveston hurricane killed at least 8,000 and was likely a Category 4 storm.

According to a 2012 study published in the scientific journal *Nature Climate Change*, global warming is likely to ratchet up the frequency of "monster storms" from once each century to an appearance every three to twenty years.

When it comes to the stormy history of the East Coast, there remains much to learn. One of the leaders in the study of ancient storms is Jeff Donnelly, a researcher based at the Woods Hole Oceanographic Institution on Cape Cod. In the *Times*, Dr. Donnelly noted that New York City has been hit just once by a Category 3 hurricane since records were kept. That storm struck 190 years ago. Hurricane Irene was a close call in the summer of 2011 but never really became a real threat.

When asked about the Chesapeake Bay region for this book, Dr. Donnelly responded that the 1667 hurricane was likely one of the most intense storms to impact the Chesapeake in the last four hundred years. "Another contender would likely be the September 3, 1821 storm," he noted. That's the very storm that Howard Pyle wrote about extensively for *Scribner's Magazine* back in 1877, relying on the accounts of elderly eyewitnesses.

What about the Great Chesapeake Bay Hurricane of 1933, Hazel, Agnes and Isabel? "The other recent storms you mentioned were all minor hurricanes or, in the case of Hazel, a major hurricane that struck far afield from the Chesapeake," Dr. Donnelly responded. "The Chesapeake has not had a major hurricane strike since at least August 18, 1879."

Researchers like Dr. Donnelly add that the threats of future storms are very real. "Recent climate model results point to a possible doubling or tripling of hurricanes threatening the eastern seaboard of the U.S. by AD 2200," he noted. "Combined with sea-level rise and the continuing concentration of population and infrastructure on the coast, this is a major concern that we should absolutely be planning for."

A question mark for the future regards whether or not coastal flooding will increase in frequency as the predicted rise in sea levels takes place. Shown here is a road covered with water from the lower Patuxent River in 1997. *Courtesy of National Oceanic and Atmospheric Administration/Department of Commerce.*

It was the change in sea levels, after all, that created the Chesapeake Bay in the first place thousands of years ago. Four hundred years seems very short in comparison, so who are we to judge that the bay isn't a work in progress? The news about the impact of climate change and rising sea levels is nothing new for Maryland officials, who are working to address the issue.

In recent years, Maryland has created a climate-change adaptation program to assess what's ahead. At the top of the list are issues such as the more than sixty-eight thousand homes and businesses located in the one-hundred-year flood plain, considering that those rare floods may become more frequent. Then there are the 371 miles of roads that are so prone to flooding that they may permanently be submerged someday soon. As many as 400,000 acres of wetlands and marshes on the Eastern Shore could be lost.

State officials are also weighing what to do with 2,500 historical and archaeological sites that predictions show are going to be underwater. Less glamorous than saving historical sites but terribly important would be the fate of thousands upon thousands of waterfront septic tanks that are soon going to be in the water rather than on dry land. According to a recent article in *Newsweek*, one county alone has 5,200 septic systems that could be

underwater. The impact on water quality may be worse than one hundred Agneses, experts note.

Again, some experts point out that the best glimpse of the future may come from taking a long look at the past. "Predicting future hurricanes or storms seems to be marginally more advanced than predicting future earthquakes, in my opinion," noted Jeffrey Halka, director of the Maryland Geological Survey in Baltimore. Halka's agency is more familiar with earthquakes than hurricanes, but it does know more than a little about the geologic history of the region.

> *With climate change, I've always read that events will become more extreme on a global level (e.g. droughty areas more droughty, wet areas more wet) and that storms may be more powerful simply because of the higher temperatures, but bringing those predictions to a local level is pretty risky.*
>
> *For shore development, the basic view of a geologist is that shores are not suitable locations for focusing development because of sea level rise. The seas have been rising for some eighteen thousand years and haven't stopped yet. In the last interglacial, sea level was some forty to sixty feet higher than now, and there is no evidence that it won't get there again. But that hasn't stopped humankind from wanting to live on or develop the shores of the world in the past and is unlikely to in the future despite any arguments that may be applied.*

Ultimately, it may be hard to gather the resources or the public will to take on something as less-than-insistent as climate change. "Global warming could increase the rate to as much as 3 feet over the next century," according to the state-funded report "An Assessment of Maryland's Vulnerability to Flooding." "It is difficult to separate the effects of sea level rise from those of land subsidence, but both contribute to greater flooding of low-lying lands. In addition to increasing the rate of sea-level rise, global warming is expected to increase the severity and frequency of storms. Coastal flooding will increase, submerging tidal wetlands, increasing erosion of shorelines, and damaging structures in low-lying areas."

According to the state's own report, "Sea level response planning is needed in Maryland; the state's current capabilities do not adequately address the three primary impacts of sea level rise (erosion, flooding, and wetland loss) and little is being done to prevent adverse effects."

Halka, the geologist, notes perceptively that not all the change has been in the climate, but to some degree there has been a change in the attitude of Marylanders. He stated:

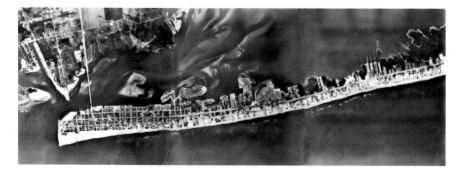

A 1962 aerial view of the Fenwick Island, Delaware resort. Many of the coastal resort towns in Maryland and Delaware are built on barrier islands that are little more than sand spits, making them highly vulnerable to hurricanes. *U.S. National Weather Service Collection.*

*In the past in the Chesapeake when shores eroded people simply up and moved their houses to the mainland or farther from the shore. This happened particularly after the 1933 hurricane, I've heard, and prior to that any number of inhabited islands were simply abandoned (Watts, Poplar, James, Holland, Lower Hooper, etc). People seemed to have a simpler view of things then. Now they build a house and then want someone else to pay for the fix when the shore erodes (e.g. the government). It's a mystery to me how we've all developed the viewpoint of being entitled.*

Perhaps it's the nature of the human condition to live in the present—there's little point in dwelling on what's in the past or worrying about a future beyond our control. But we should all understand that there's a storm coming. And we've been warned.

# WEATHER SIGNS AND RECORD WEATHER EXTREMES

Legendary Speaker of the House Tip O'Neill once famously said, "All politics is local." He was referring to the fact that people care about the issues that affect their communities, their families, their homes. To paraphrase O'Neill, "All weather is local." A tornado in the next town over is a curiosity; a tornado in our backyard is a matter of life and death.

When it comes to record-setting weather, it's a little hard to find benchmarks for the hottest, the coldest, the windiest and the snowiest conditions around the Chesapeake Bay. A heat wave in Baltimore is curious to people in Easton on the Eastern Shore, but they are far more interested in what the mercury in the thermometer on the deck says. What follows is a sampling of some of the weather extremes from the Chesapeake region since official records were first kept starting in 1884. It is by no means all-inclusive of those local weather extremes.

## Hottest Days

- 109 degrees on July 10, 1936, in Baltimore
- 105 degrees in downtown Baltimore on June 29, 1934
- On July 26, 2010, the temperature hit 105 degrees in Easton
- In recent years, there has been a trend toward hotter summers overall. In 2011, NOAA records showed the Delmarva Peninsula experienced

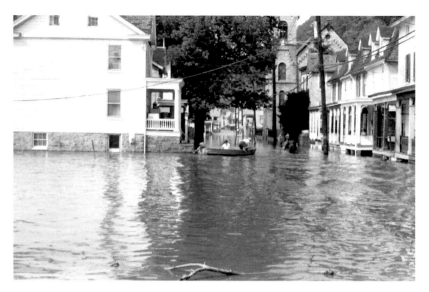

With the streets under several feet of water, residents of Port Deposit, Maryland, used boats to reach their flooded homes in the wake of Tropical Storm Agnes in June 1972. *Courtesy Historical Society of Cecil County.*

A meteorologist works at the console of the IBM 7090 electronic computer in the Joint Numerical Weather Prediction Unit, probably around 1965. The computer was used to process weather data for short- and long-range forecasts, analyses and research. *Courtesy U.S. Weather Bureau.*

its hottest twelve months since record-keeping began in 1895. It remains to be seen if this was a fluke or a trend.

## Coldest Days

- Minus seven degrees in downtown Baltimore on February 10, 1899, during the Great Arctic Outbreak
- Minus seven degrees in downtown Baltimore on February 9, 1934
- Minus seven degrees on January 17, 1982, in Easton
- Minus ten degrees on January 13, 1912, in Sudlersville
- Minus forty degrees on January 13, 1912, in Oakland (western Maryland). This stands as the coldest recorded temperature in Maryland.

An artist captures the lonely fury of an approaching storm at the Drum Point Lighthouse. The artist notes, "I fished and boated around this lighthouse back in the early 1970s when it was still at its original location at the mouth of the Patuxent River. It was rather derelict at that time. Fortunately, it was moved to the Calvert Marine Museum at Solomons, Maryland, just a few years later. My summer studio is near there, and I always admire the beautifully restored lighthouse when I visit the museum." *Painting by Harry Richardson.*

# HEAVIEST SNOWS

- 77 inches of snow fell during the winter of 2009–10 in Baltimore. In 2002–3, there was 58.1 inches of snow. The next-biggest winter was clear back in 1898–99, when the city received 51.1 inches of snow.

# RAIN

According to National Weather Service records, 14.68 inches fell at Westminster in Carroll County and 13.85 at Woodstock along the Patapsco River in Howard County during Tropical Storm Agnes. The previous twenty-four-hour record had been set at 7.31 inches in Elkton on August 11–12, 1928.

# NOTES ON THE SOURCES

Writing this book required a number of sources that ranged as widely as dusty tomes and brittle newspaper clippings to the latest forecast online. Whenever possible, I relied on original accounts of storms published in contemporary books, magazines and newspapers. Of course, many of these resources are now available in digital format, but there is something more rewarding about paging through an actual book—the older, the better. I suppose it's a little like the difference between walking in a snowstorm and watching one on TV.

## NEW WORLD TEMPESTS

Books that served as sources for the historical context of the Chesapeake region in the 1600s include *The Founding of Maryland* by Matthew Page Andrews (New York: Williams and Wilkins Company, 1933) and *Narratives of Early Maryland 1633–1684* by Clayton Colman Hall (New York: Barnes & Noble Inc., 1910). Also, Hulbert Footner's wonderful book *Rivers of the Eastern Shore* (New York: Farrar & Rinehart, 1944) is entertaining and informative. The National Oceanic and Atmospheric Administration (NOAA) had an excellent summary of early Chesapeake Bay hurricanes of that era. Research done for "Delmarva Architecture," a lengthy article I wrote for *Delmarva Quarterly*, also provided much background material. I'd also like to credit Professor Nancy Tatum and Professor Rich Gillin for bringing Shakespeare and Elizabethan England alive in their excellent English classes at Washington College in Chestertown.

# GEORGE WASHINGTON'S STORM

There are several good sources for George Washington's account of the storm that passed over Mount Vernon. One such source would be *Hurricane of Independence: The Untold Story of the Deadly Storm at the Deciding Moment of the American Revolution* by Tony Williams (Naperville, IL: Sourcebooks, 2008).

# BALTIMORE VERSUS CHARLESTOWN

The primary source for this chapter was *At the Head of the Bay: A Cultural and Architectural History of Cecil County, Maryland*, compiled and edited by Pamela James Blumgart (Crownsville, MD: 1996), an excellent, wide-ranging history of the northern Chesapeake. I also drew on material from my previous book *Delmarva Legends & Lore* (Charleston, SC: The History Press, 2010). Perusing the *Niles Weekly Register* also revealed a few tidbits about Charlestown and Chesapeake Bay shipping.

# FIRE AND NATURE'S FURY DURING THE WAR OF 1812

An account of the storm itself comes in large part from British officer George Gleig as recounted in *History of Maryland: 1812–1880* by John Thomas Scharf (Baltimore: John B. Piet, 1879). Background material about the War of 1812 and the burning of Washington is drawn from research done for my previous book *1812: Rediscovering Chesapeake Bay's Forgotten War* (Rock Hill, SC: Bella Rosa Books, 2005).

# THE GREAT ICE BRIDGE OF 1852

When writing about this extraordinary feat, one should begin by noting that it's a very well-known local legend. Standing on the river shore today, it's also extraordinary to believe not only that the Susquehanna froze nearly solid but that someone was brave or foolhardy enough to cross the frozen river in this manner. For inspiration, there is a large framed print of the ice bridge in the microfilm research room at the Historical Society of Cecil County in Elkton. Unfortunately, the ice bridge was built in the very last years before photography became widely available, and as far as I know, there are no

photographs of the crossing. Details about that particular winter and the ice crossing came from a number of published sources, including *The Pennsylvania Weather Book* by Ben Gelber (New Brunswick, NJ: Rutgers University Press, 2002), as well as the official report made by the United States postmaster general to Congress explaining delays in mail service (Congressional edition, Washington, D.C.: Government Printing Office, 1856), which can be found online. Also useful were the *Mechanics' Magazine and Journal of Science, Arts, and Manufactures* 56 (1852) and an excerpt from the *Philadelphia, Wilmington and Baltimore Railroad Guide of 1856*, both readily available online. The *Niles Weekly Register* had several anecdotes about the frozen bay and how people skated on the ice or crossed between the Western and Eastern Shores on the ice. James A. Michener's novel *Chesapeake* (New York: Random House, 1978) and William Warner's work of journalism *Beautiful Swimmers: Watermen, Crabs and the Chesapeake Bay* (New York: Penguin Books, 1982) provide lyrical descriptions on winter on the bay.

## FLASH FLOOD ON THE PATAPSCO

This devastating event is not very well known today, but it seemed to be such an incredible weather event that it deserved inclusion in a book about the Chesapeake's great storms. Information comes from several small books published about the history of Ellicott City. The first were two books by Celia M. Holland: *Ellicott City, Maryland 1772–1972* (Bladensburg, MD: Parkway Press, 1972) and *Landmarks of Howard County, Maryland* (Ellicott City, MD: Bicentennial Commission of Howard County, 1972). Another useful book was *The Orange Grove Story: A View of Maryland Americana in 1900* by Thomas L. Phillips (Washington, D.C.: Thomas L. Phillips, 1972). Finally, I was lucky enough to obtain an 1868 illustration of the flood in *Harper's Weekly*.

## TEMPTING FATE

I first came to know about this Chesapeake Bay tragedy while researching my earlier book *Delmarva Legends and Lore*. Much of the overall information comes from *Shipwrecks on the Chesapeake* by Donald Shomette (Centreville, MD: Tidewater Publishers, 1982). While writing this book, I was able to pay a visit to the Smithsonian's exhibit "On the Water: Stories from Maritime America," which provided helpful insights into the wreck of the

SS *Central America* and the key role that water transportation played in the nineteenth century. There was also an interesting exhibit there on rescue techniques in the days before U.S. Coast Guard helicopters. Accounts of difficult voyages on the Chesapeake come from several sources, including *Life in the South* by Catherine Cooper Hopley (New York: Da Capo Press, 1863), *Lucy Larcom: Life, Letters, and Diary* (New York: Houghton Mifflin, 1894) and *The Diary of Philip Hone* (New York: Dodd, Mead and Company, 1899). Some information also comes from *New Jersey Weather Book* by David Ludlam (New Brunswick, NJ: Rutgers University Press, 1983) and *Golden Light: The 1878 Diary of Captain Thomas Rose Lake* (West Creek, NJ: Down the Shore Publishing, 2003). This last is a fine book for any Chesapeake Bay history buff, beautifully printed and with fascinating explanations of the diary entries made by the editor. I was also able to discover several contemporary accounts of the 1878 hurricane in newspapers of the day, mostly found on microfilm. Several newspaper reports mentioned the *Express* disaster or other shipwrecks around the Chesapeake. What one finds about journalism of the day, however, is that there are rarely any quotes or firsthand accounts from survivors.

# KEEPERS OF THE LIGHT AND SENTINELS IN THE STORM

There are several excellent books on Chesapeake Bay lighthouses, and I drew on several for this chapter, including *The Lighthouses of the Chesapeake* by Robert de Gast (Baltimore: Johns Hopkins University Press, 1973) and *Lighthouses of the Mid-Atlantic Coast* by Elinor DeWire (Stillwater, MN: Voyageur Press, 2002). Also helpful regarding the effect of ice on screwpile lighthouses were original reports made to Congress, such as "Annual Report of the Light-House Board to the Secretary of the Treasury for the Fiscal Year Ended June 30, 1893" (Washington, D.C.: Government Printing Office, 1893). Lighthouses have a huge following today, and I made use of several good websites devoted to lighthouse information and individual lighthouses, including www.concordpointlighthouse.org, www.tpls.org (Turkey Point Light Station) and the University of North Carolina lighthouse history site, www.unc.edu/~rowlett/lighthouse/md.htm.

## SNOWBOUND

I wrote this chapter during a Maryland winter when there was very little snow, so exploring these great blizzards was a way to experience winter vicariously. Several newspaper accounts found on microfilm were helpful. Also useful was "The Blizzard of 1899" chapter in *The Sun Almanac* (Baltimore: A.S. Abell Co., 1900) and "History of Maryland Weather" by James Dawson, an expanded version of an article that originally appeared in the *Tidewater Times*. The Maryland Weather Service gave accounts of the storms in its published volumes. The NOAA site also has detailed accounts of the worst Maryland winters from a meteorological standpoint at www. erh.noaa.gov.

## HOW CURIOUS

For the most part, the Maryland Weather Service speaks for itself in this chapter, providing most of the background material from its three-volume series published from 1893 to 1910. I was also able to find various related publications from that era to provide context.

## THE ONCE-IN-FIVE-HUNDRED-YEARS STORM

There are many accounts of Tropical Storm Agnes, but one of the best local narratives was "Four Days to Remember," an article by Clark Samuel published in the *Havre de Grace Record* on June 28, 1973. The late Mr. Samuel was at that time a well-known and well-respected newsman who had worked at some of the bigger dailies in the 1940s and 1950s before settling for a "retirement job" at papers such as the *Record* and *Cecil Democrat*. His account is thorough, well written and unembellished. Also helpful, but written from a more personal perspective, was the article "It Began with a Phone Call" by Bob Davis, published in the *Havre de Grace Record* on June 28, 1973.

# To Hell and Back Again with Hurricane Hazel

Again, the NOAA site provides good background material on Hurricane Hazel. I also found several mentions of Hazel in more unlikely places, such as survivors' accounts published by WBAL-TV Baltimore and patch. com. Also helpful was "History of Maryland Weather" by James Dawson, noted previously.

# The Day the *Marvel* Went Down

The sinking of the old sailing ship–turned–tour boat received a lot of press coverage in its day, so here I turned to newspaper accounts, primarily in the *Annapolis Capital* and *Salisbury Times*. In 2003, *Washingtonian* magazine published a detailed account of the disaster that was useful. Some information also comes from the original *Life* magazine story about the trip *Marvel* took from Chesapeake Bay to Miami in happier times. Donald Shomette's book *Shipwrecks on the Chesapeake* was useful for providing an account of what happened during the storm. The best information for this chapter, however, came from the records of the U.S. Coast Guard inquiry into the sinking. These documents provide a wealth of information about the weather that day, the condition of the ship, the actions of the crew and passengers and the rescue efforts. NOAA's site offers details about Hurricane Connie.

# City on the Sand

Information for this chapter comes from a number of sources. One of the most helpful was a *Baltimore Sun* article, "50 Years Ago Today, Ocean City 'Was Washing Away,'" by Scott Dance, published Tuesday, March 6, 2012. The one I found most interesting was the *Scribner's Magazine* article by Howard Pyle in which he shares accounts by Chincoteague residents of the great storm surge wave that swept ashore during the hurricane of 1821. Once again, journalism of the day didn't rely on quotes or on naming sources, but Pyle effectively shared the story of this event as presumably told to him by those who had survived the storm decades before.

# In the Deep Midwinter

The Chesapeake region experiences such weather extremes from one season to another that from the perspective of a hot August day, it seems beyond reckoning that in a few months there might be a snowstorm or ice storm that proves deadly. There were good accounts of the storms mentioned here in several newspapers found on microfilm or in the clipping files of the Historical Society of Cecil County. The *Quarterly Journal of the Royal Meteorological Society* 20–21, published in Great Britain in 1894, gives some perspective on "the weight of snow."

# Isabel Surges into Chesapeake and Goodnight, Irene

Data and information from NOAA provide all the source material for these recent storms.

# The Great Derecho of 2012

Various news sources were used for this chapter, including the *Washington Post* weather blog, WJZ-TV and the NOAA derecho page online.

# A Perilous Past, a Stormy Future

The information in this chapter could be seen as controversial in that it deals with global warming, sea-level rise and predicting future storms. Several articles provided useful source material, including "Climate Change May Drastically Alter Chesapeake Bay, Scientists Say," in www.smithsonianscience.org, published November 24, 2009. A 2001 article in the *New York Times*, "Experts Unearth a Stormy Past" by Andrew C. Revkin, helped lead me to paleotempestologists who were kind enough to comment on Chesapeake Bay history. "The End of Winter," by Bryan Walsh, published in *Time* magazine on January 23, 2012, offered some captivating thoughts on climate change. "Weather Panic: This Is the New Normal (And We're Hopelessly Unprepared)" by Sharon Begley, *Newsweek*, June 6, 2011, was another thoughtful piece. A state report entitled "An Assessment

of Maryland's Vulnerability to Flooding" made for very dry reading, but it offered excellent insights into how susceptibility to flooding may be changing. Finally, Jeffrey Halka, director of the Maryland Geological Survey in Baltimore, corresponded with me regarding some of the finer points of Chesapeake Bay geologic history and vetted the chapter in detail.

## WEATHER SIGNS AND RECORD WEATHER EXTREMES

For the weather records, weather.com and weatherunderground.com were helpful. The source for many of the poems used at the beginning of the chapters is *Poet's Choice: Poems for Everyday Life* by Robert Hass (Hopewell, NJ: Ecco Press, 1998).

# INDEX

# ABOUT THE AUTHOR

David Healey is a Maryland native who has written frequently about the people and places of the Delmarva Peninsula. His articles have appeared in *American History*, *Chesapeake Bay* magazine, *Chesapeake Life*, the *Washington Times* and *Delmarva Quarterly*. He is also the author of two previous nonfiction books, *1812: Rediscovering Chesapeake Bay's Forgotten War* (Bella Rosa) and *Delmarva Legends & Lore* (The History Press). A graduate of Washington College in Chestertown and the Stonecoast MFA program in Maine, he has written several novels, including *Sharpshooter* (Penguin Putnam) and *The House that Went Down with the*  *Ship* (Bella Rosa). He enjoys working around his old house and has been known to drive his family crazy by making frequent stops to read historical markers at the side of the road. Visit him online at www.davidhealey.net.

*Visit us at*
www.historypress.net
..............................................................
*This title is also available as an e-book*